マーカーテクニック

CREATIVE MARKER TECHNIQUES
In Combination with Mixed Media

目　次

C O N T E N T S

平野拓夫
TAKUO HIRANO
(株)平野デザイン設計　代表取締役
多摩美術大学立体デザイン科科長・教授

　デザインという言葉は，もともと「意志決定を表現する」という
もので，*design* の *de* は『外に』を意味する接頭語で，*sign* は『しる
す・署名』の意味を持った語幹である。

　工業デザインにおいての表現は，スケッチ・図面・レンダリング・
モデルなどで行われる。また，最近はコンピュータなども大いに活
用されている。

　デザインの行為は人が行うものであり，人の未来に向けての思い
込みや心が介在するもので，それを表現し，啓蒙するものである。
レンダリングはその未来を予想する精密な想像図で，デザインの決
定に関わる重大な役割を持ち，特にデザイン考案者の心やイメージ
が強く表現されるものである。

　ここに，この道の日本での第一人者と評価されている清水吉治氏
の作品が収録されたものが出版されることは，われわれデザイナー
の世界において大きな意義を持つものと思う。

The word 'design' originated from the meaning 'to express the decision of ones intention'. If one analyzes this sentence, 'de' is a prefix which denotes 'outside', and 'sign' has the meaning 'to describe and a signature'.

Industrial designs are expressed in the form of sketches, blueprints, renderings and models, in recent year the computer is also used a great deal.

Design should be expressed and enlightened by man as man's thought for the future and his intention which lies between design. Rendering is the accurate imagery of future drawing and plays an important role in making decisions over design. It is especially important that the intentions of the designer and the image should be strongly expressed in the rendering.

I am sure that the publication of this collection of work by Mr. Yoshiharu Shimizu, who is rated as a leader in the field of design, will have a great significance in the world of design.

Takuo Hirano

Director, Hirano Design Co. Ltd.
Head and Professor in the Solid Design Department of the Tama Art University.

豊口　協
KYO　TOYOGUCHI
（社）日本インダストリアルデザイナー協会理事長
東京造形大学学長

清水吉治さんの仕事や人柄については，日本はもちろん海外でもよく話題にのぼる。

「日本から来るデザイナーには，スライドや講演を中心に，理論的な展開に終始する人が多いが，清水吉治さんは，それにデザイナーとして基本的な技術の世界を，実際に目の前でみせてくれる貴重な人材です」と。

清水さんが，頭の中でイメージしている世界が，一枚の紙の上にまるで魔法の筆がそこにあるように，華麗にしかも力強く表現されてゆく。

デザインを学ぶ多くの若い人びとは，この技術の高さと，表現されてゆく物の世界に魅了され感銘をうける。

東南アジアのある女子学生は，「涙が出るほど感動をうけました」と語ってくれたことを思い出す。

「まるで，スケッチに描かれた物が，生きて語りかけてくるような不思議な感情にとらわれました」と語った学生もいた。

スケッチは，単に物の形を正しく表現することではない。そこに描く人の人格や思想が付加されていなくてはならないし，あくまでも見る人の心へのメッセージが，そこになくてはならない。

マーカーやパステルという表現素材は，まるで清水吉治さんのために開発されたもののように思える。

この本のページを開いてゆくと，自然にデザインスケッチの世界にひきずり込まれてゆく。

マーカーを手に，パステルを手に，清水さんの細やかな指導の世界にひき込まれてゆく。これで十分であるという事はあり得ないという言葉が，まさに清水さんの基本的な考えかたかも知れないが，心で描き出した，今まで誰も成し得なかった，価値ある出版物である。

The work and personality of Mr. Yoshiharu Shimizu are things that are often talked about not only in Japan, but also overseas. They say "Most designers from Japan show slides and give theory lectures from beginning to end, but Yoshiharu Shimizu is exceptional. He also demonstrates the basic technical world before our very eyes. He is a truly valuable character to have in the design world".

Mr. Shimizu can transfer an image that he has in his mind onto a piece of paper as if he has waved a magic wand with a magnificent and strongly expressive style. Most young designers are attracted and overwhelmed by his high standard of skill and the area of his work.

I recall a comment made by an Asian female student. She told me that she was so deeply impressed by his work that it made her cry. Another student said that he was in the grip of a strange feeling; as if the sketch was actually speaking to him.

Sketching is not merely the act of expressing an object accurately onto paper. It must also contain the perconality and thoughts of the artist. A message to the people should also be included.

Expressive tools such as markers and pastels seem to have been invented especially for Mr. Shimizu.

The opening page of this book will automatically draw one into the world of design sketching.

With markers and pastels in one's hand, one will immediately become a part of Mr. Shimizu's world of magic. It may be his basic thought process that a work is never finished, but this book has been processed with a spirit that is unprecedented. This is an extremely valuable publication.

Kyo Toyoguchi

Managing Director of Japan Industrial Designer Association
President of Tokyo Formative Art College.

はじめに

　私はプロダクトデザイナーの立場から，企業内デザイナー，各デザイン団体主催スケッチ講習会，デザイン事務所，美術系大学，専門学校，技術高校等幅広くデザインスケッチ指導をしているが，最近この方面から，次のような要望が多くある。

　企業内デザインセクション，デザイン事務所においては，製品の多様化，多品種にともない製品デザイン開発サイクルが一段と早くなり，デザイナーはスケッチワークに時間をあまりとれなくなってきている。

　いいかえれば，デザイナーが日常の仕事のなかで直面する限られた時間内で，完成度が高く，訴求力をともなったスケッチをより早く，多数描く必要があり，時にはドラマチックな表現も要求される。

　このような条件を満たすスケッチ技法には，やはり即乾性と簡便性という点で現在，最も使用頻度と実用性の高いマーカーをベースに，パステル等の画材を併用して表現する，いわゆるドライメディアによるスケッチ表現が最適であろう。

　従来は社内のベテランデザイナーが，新入デザイナーに対しスケッチテクニックを指導していたが，最近は，前述のように製品開発プロセスが多忙なため，充分な指導ができないのが現状である。

　したがって，ビギナーデザイナー個人でスケッチテクニックを習得していかなければならないが，その際に参考となるテキストがないか。

　又，新入デザイナーを対象にした社内のスケッチ研修会の時にも使用できる技法書がほしい等。

　美術系大学，専門学校，技術高校等のデザイン教育現場においては，学生の教科書として分かり易く，ビジュアライズされたデザインスケッチ技法書がほしい。

　多様なスケッチ技法を，スケッチ作成スタートの時点から完成までのプロセスを出来るだけ細かく，段階的に把握したいのが学生であり，この点が充分留意されたデザインスケッチ技法書がほしい。

　透視図法は重要だが，それにこだわらないのびのびしたフリーハンドパースによるデザインスケッチ作例も多くみたい。

　マーカー，パステルといったドライメディアを主に使って描くプロダクトデザインスケッチ技法が知りたい。等等。

　そこで，以上のことから技法書の必要性を強く感じ，要望を出来る限り反映させ，一冊の本にまとめてみた。

　本書では，マーカー，パステルを主体にしたプロダクトデザインスケッチ技法のスケッチデモンストレーション（スケッチ作成スタートの時点から完成にいたるプロセスを細かく段階的に紹介）を多数載せた。

　そして，見て理解してもらうことを重点に，なるべく文による説明を少なくしてある。

　また，短時間にアトラクティブなデザインスケッチが描けるテクニックを紹介してあるので，プロダクトデザイナーを志す方々だけでなく，製品イラストに興味をもつ方々，コンプリヘンシブ関係の方々にも参考に使って頂けたらと願っている。

As a product designer, I am in a position to teach design sketching in a variety of places such as companies (employee designers), sketch classes arranged by various design organizations, design offices, art universities, speciality colleges, technical high schools, etc., and recently I often hear the following comments from the people concerned.

Owing to the fact that the speed cycle of product design development is rapidly increasing in accordance with the diversification and wide range of products, the time scale within which designers who work for design companies must produce results is becoming shorter and shorter.

In other words, designers are now called upon to produce as many appealing sketches as possible and have them finished within the limited amount of time available during their working hours. Not only this, but on occasion dramatically expressive works are requested.

Naturally, the most suitable sketch method to meet these requirements is the so-called Dry Media sketch. In this method such materials as pastels are used to express the sketches together with base markers which are now most frequently used owing to their practicality and quick-drying abilities.

It used to be that the veteran designers in each company would teach their sketch techniques to the new designers, but now, owing to the above, such time is no longer available. These new designers, therefore, now have to learn their sketch techniques by themselves but are there any textbooks available to offer them good guidelines and set them on the right road for the future?

There is an increasing amount of companies around at the moment that desire sketch technique textbooks for use in study and training courses for these new designers.

Simple and graphic sketch textbooks and guidance books are required for teaching purposes by art universities, special colleges and technical high schools.

It is natural that students should wish to grasp the minutest techniques of sketching to see them through a sketch from beginning to end. Consequently they need a design sketch technique book that will provide this service.

Although the drawing methods for perspective works are important, some people would like to see more examples of design sketches in free hand perspective without having to stick to the guidelines.

Some people are interested in learning the techniques of product design sketching drawn mainly in the Dry Media method using markers and pastels, etc.

Having pondered upon the above, I strongly felt the necessity of having an available technique book. I therefore did my best to compile a book that reflects as many of the above comments as possible.

I have included many examples of product design sketch techniques based on markers and pastels within the book (with step-by-step process explanations from beginning to end).

Additionally, I have tried to keep the explanatory sentences as short as possible and concentrate on the aural aspect of understanding.

Furthermore, the book introduces people to the art of drawing attractive design sketches in the shortest possible time.

I hope this volume will not only be used as a reference book by people who wish to become designers, but also by tgose who have an interest in the comprehension of product illustration.

装幀・レイアウト＝大貫伸樹＋伊藤庸一＋竹田恵子
Book Design＝Shinju Onuki＋Yoichi Ito＋Keiko Takeda

Creative Marker Techniques
Copyright © 1990 Graphic-sha Publishing Co., Ltd.
1-9-12 Kudankita, Chiyoda-ku, Tokyo 102, Japan.

Printed in Japan

First Printing, September 1990

デザインスケッチについて
DESIGN SKETCHES

❶デザインスケッチは デザイナーの必須テクニック である

　デザイナーは自分のイメージしたものを具体化し，第三者に正しく伝え理解を得る必要がある。

　その伝える方法としては，いきなり三次元立体（モックアップ）を製作して見せるとか，三面図を描いて見せる等あるが，いちばん早く簡単にできるのが，スケッチを描いて見せることであろう。

　第三者に伝えるためのデザインスケッチは，その形体，構成，素材，色彩など，誰が見ても充分理解できるように，正確かつ美しく描かれていなければならない。

　いくら素晴らしいデザインであっても，デザイナーのスケッチ表現技術が未熟であれば，フォルムが歪んで見えたり，立体感に欠けて見えたりして，完成度の低いプレゼンテーションスケッチとなり，第三者の理解を得ることは難しく，そのデザインとデザイナーの価値は著しく低下することになる。

　ところで，多面的なデザインをつくりだすことを目的とした企業やデザイン事務所等のシステマチックなデザインプロセスでは，デザインスケッチワークに費やす時間にはおのずと限界があり，デザイナーは時間と戦いながらスケッチ表現を進めることになる。

　このことから，デザイナーには，誰が見ても，そのデザインの形体，構成，素材，色彩等が理解できるようなスケッチを，短時間に描けるテクニックの習得が必須条件となる。

　スケッチテクニックの上達には，理論や知識よりも多くのスケッチを描くことが一番の早道である。

　手始めに，本書に載せてあるスケッチ作例をそのまま描いてみることをおすすめしたい。

① DESIGN SKETCHES ARE INDISPENSIBLE TECHNIQUES FOR DESIGN

It is the designer's job to make concrete his own image and then correctly impart it to a third party and secure his/her understanding.

This can be done by producing a quick mock-up or a 3 dimensional plan, but the quickest and easiest way is to come up with a sketch.

The shape, construction material and color of the design should be imparted to this third party in a concise but beautiful manner in order to gain their immediate recognition.

Should the designer have a low skill level in expressing sketches, the form could be distorted or lack solidity which will consequently lower the valuation marks awarded it by the third party despite the high quality of the actual design. This will, of course, leave the viewer with a lack of understanding and will greatly decrease the value of the design and the designer.

However, in the systematic design process carried out by design offices, despite the aim to produce high quality diversified designs, the time spent on the actual design is limited. This means the designer is placed in a position where he is forced to fight against the clock in order to work on his sketches.

Consequently, it becomes an indispensable condition that the designers must learn the technique of how to draw sketches that anybody can immediately relate to with regards to the design shape, construction material and coloring in the shortest possible time period.

The quickest way of improving ones sketching technique is by drawing as many sketches as possible rather than learning the theory alone. To start with, I would recommend that the sketch examples within these pages are drawn.

❷パースペクティブ（透視図）

　一般的に，デザイナーが描く透視図には，図学による方法とフリーハンド（感覚的）による方法の二つがある。

　図学による方法は，透視図法が複雑で作図に時間がかかりすぎるので，プロダクトデザイン関係ではあまり使われていない。

　しかし，透視図の作図をある程度理解し，感覚的に透視図を身につけておけば，フリーハンドパースが描きやすいのは間違いないところであろう。
注）本書は透視図法書ではないので，くわしくは他の透視図専門書などを参考にされたし。

　フリーハンドパースとは，描く物の大きさや消点，奥行きなどを"なれ"によって決めて，描いていく方法で，正確に表現するにはある程度の練習をつまなければならない。

　だが，複雑な作図がいらないフリーハンドパースは，早く描けるので，製品開発に忙しい，ほとんどのプロダクトデザイナーは，この方法でスケッチ表現してるといっても過言ではない。

　このようなことから，本書に載せてあるスケッチ作例の多くはフリーハンドパースでのびのびと描いてある。

② PERSPECTIVE

Generally there are two ways of drawing perspectives; the drawing method and the freehand method (drawing by sense).

The drawing method is not often used for product designs as perspective drawing is complicated and much time is spent in drawing figures. However, if one learns the feel of drawing perspective pictures using the basic understanding of perspective drawing, the free-hand method would then certainly become easier.

NB: This book has not been constructed with perspective drawing alone in mind. For more information on this subject see the other specialist books.

The free-hand perspective method requires quite a high standard of skill as the size, focus and width of the object must be decided with the use of one's experience.

It would be an exaggeration to say that most product designers use this method of expressing their sketches. The free-hand style has no requirement of figure drawing, but can be completed within a short period of time.

Owing to the above, most of the sketches introduced within these covers have been drawn by the free-hand perspective method in a free and easy style.

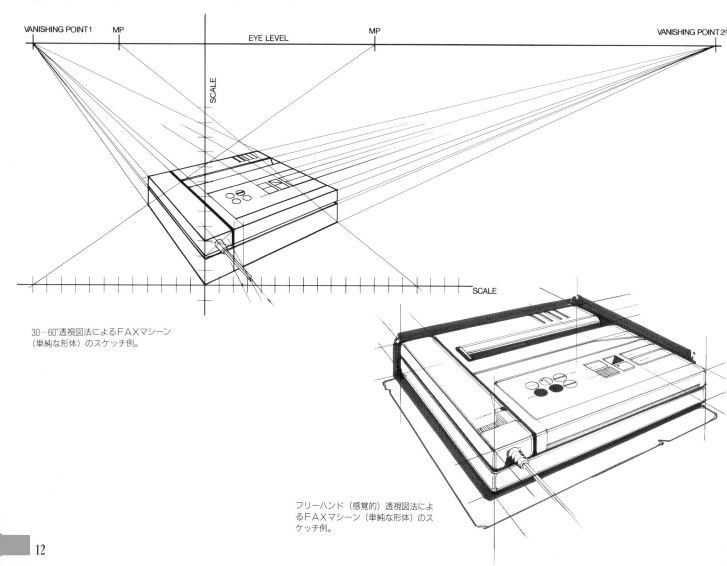

30—60°透視図法によるFAXマシーン（単純な形体）のスケッチ例。

フリーハンド（感覚的）透視図法によるFAXマシーン（単純な形体）のスケッチ例。

❸美しく見える角度の選択

　同じ物体を描いても，見る角度によってずい分と感じが違って見える。

　デザインスケッチする物体の最も美しく見えるアングルを選ぶことが，魅力的なデザインスケッチを表現する条件ともいえる。

　図A，Bは，同じパソコンであるが，アングルを変えて表現してある。

　図Aは，パソコンの三面（正面，上面，側面）の面積量がほぼ等しく見えるアングルで表現されているため，変化にとぼしく，退屈感を与え魅力的なスケッチとはいえない。

　図Bは，パソコンの三面の面積量がそれぞれ違っているので，変化にとみ，魅力的なアングルの設定といっていい。

　又，最も表現したい正面部分の面積の量を多くとってあるため，デザインが理解し易い。

　なお，本書のスケッチ作例では，製品が最も魅力的に見えるアングルを選び，描いたので参考にされたし。

③ A SELECTION OF BEAUTIFUL ANGLES

A single object can be portrayed in a completely different style depending on the angle from which it is viewed. Consequently, a designer requires the ability to select the best angle for drawing an object in order to express it in an attractive sketch.

Pictures A and B are the same personal computer simply drawn from different angles. Picture A is drawn from an angle where the areas of the three sides (front, top and side) can be viewed in almost equal size. This lacks in variety and gives off a dull impression. It is not a good example of an attractive sketch.

On the other hand, picture B has been drawn from an angle which depicts the areas with different sizes in order to produce a touch of variety into the picture. This is a much more attractive angle setting. Furthermore, the design of the object is easy to understand as the most important part, the front, has been expressed with the largest area.

This book will doubtless be of valuable guidance as all of the sketches within were drawn from the most selected and attractive angles.

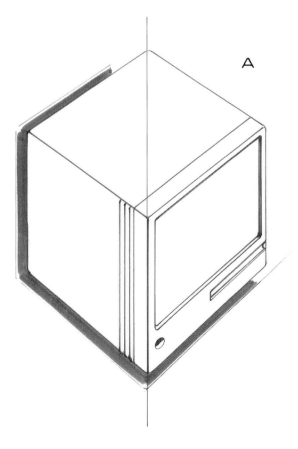

A

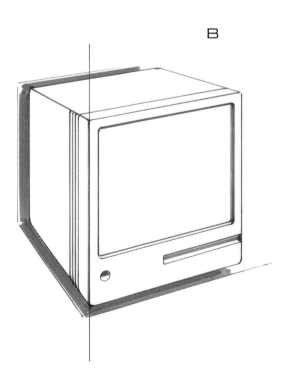

B

❹デザインスケッチの種類

A) メモスケッチ（MEMO SKETCH）
　サムネイルスケッチ（THUMBNAIL SKETCH）
　スクラッチスケッチ（SCRATCH SKETCH）

　メモスケッチとはイメージしたものを記憶しておくためのスケッチ，サムネイルスケッチは親指位に小さく描くスケッチのことで，スクラッチスケッチはなぐり描きスケッチの意味。

　いずれのスケッチも，イメージしたものをメモしたり，デザインの基本構成を検討するためのスケッチなので，ディテールは省略しフリーハンドで速く表現する。

　特定のスケッチテクニック，使用画材はないが，多数のクイックスケッチを描くので，一般的にはボールペン，サインペンが使い易い。

④ VARIOUS DESIGN SKETCHES

A)　Memo Sketch
　　Thumbnail Sketch
　　Scratch Sketch

　A memo sketch is a sketch in which one inserts a record of images, a thumbnail sketch creates a sketch in the size of a thumbnail, and a scratch sketch is one that is drawn up in a hurry.

　Since all of these are sketches for taking note of images or studying the basic design structures, they should be expressed swiftly in a free-hand style with no added details. There are no specific sketch techniques nor material requirements for these sketches, but in general ball-point pens or felt-tip pens are recommendable for easiness as a great number of sketches will be involved.

B) ラフスケッチ（ROUGH SKETCH）
　　コンセプトスケッチ（CONCEPT SKETCH）

コンセプトスケッチ，ラフスケッチとも概略スケッチの意味で，コンセプトレンダとかプレゼンテーションラフスケッチとも呼ばれている。

まとめられた様々なデザインアイデアを，比較検討するためのスケッチで，誰が見ても理解できるように表現する。

特定のスケッチ技法はないが，一般的にはボールペン，サインペンでパースペクティブドローイングし，マーカー，パステル等を使い，フォルム，材質，色彩，キャストシャドウ，バックグラウンド（必要があれば）等を簡潔なタッチで早く描く。

B)　Rough Sketch
　　Concept Sketch

Both the rough and concept sketches are outline sketches. They are also known as concept renderings or presentation sketches.

As these are the sketches from which one will compare and study the various design ideas that have been put together, they have to be clearly expressed so that anyone can understand them.

There are no specific sketch techniques, but usually ball-point pens and felt-tip pens are used for the perspective drawings, and markers and pastels for the form, texture, coloring, shadows and background (if necessary), all laid down with a quick and simple touch.

C）レンダリング（RENDERING）

　既にデザインが決定した製品等のフォルム，材質，色彩，パターンなどを精緻かつ正確に描き込み，誰が見ても充分理解できるように表現された完成予想スケッチをいう。

　特定のスケッチ技法はないが，時にはドラマティックに表現したり，デフォルメして訴求力のつよい表現にしたりする場合もあるが，オーバードローイングにならないよう注意が必要である。

　最近は製品のデザイン開発テンポが早く，スケッチワークに費やされる時間が少なくなっている。

　このため，時間のかかるレンダリングを描かないで，コンセプトスケッチ或いはラフスケッチにディテール等を描き込んだり，バックグラウンドをつけたりしてコンセプトスケッチ，ラフスケッチの完成度をあげ，これをレンダリングとする例が非常に多い。

　したがって本書では，コンセプトスケッチ，ラフスケッチに描写面での付加価値をつけたいわゆる"コンセプトレンダ"の作例を多く展開してある。

　又，掲載した全てのスケッチ作例には，コンセプトレンダに適した画材（マーカー，パステル等）が使われている。

C) Rendering

　This is a conceptional sketch of the completed artical with all accurate details of the form, texture, color and pattern for aurally clear understanding.

　There are no special technqiues at this stage of the drawing, but it will be necessary on occasion to add some strongly appealing form and dramatic expression. However, one should be careful not to overdraw this.

　Owing to the steadily decreasing amount of time spent on sketches in recent years, there are cases where rough and concept sketches are touched-up with detail and background to produce a rendering as opposed to starting the time-consuming work from scratch.

　The most suitable materials (markers, pastels, etc.) for rendering have been used in all examples throughlut this book.

本書のスケッチ作例で使用した
主な用具、画材について

THE MAIN TOOLS AND MATERIALS
USED TO DRAW THE SKETCHES INCLUDED IN THIS BOOK

コンセプトスケッチ作例

EXAMPLE OF CONCEPT SKETCHES

❖マーカー

マーカーは今から25年前頃から使われだし，その卓越した機能性（速乾性であること，取り扱いが簡便であること等から飛躍的にスケッチワークが速くなる）から今日では，プロダクト，グラフィック，インテリア，ファッション，建築デザイナー等の必須画材の一つとしてすっかり定着している。

多種多様なマーカーが市販されているが，ここでは，通常われわれが使用している主なものを採り上げた。

❖コピック
太描きと細描きが一本についているツインタイプで，コピーのトナーを溶かさない速乾性マーカー。溶剤にアルコール系を使っているので臭いが比較的ソフト。

❖パントンマーカー（油性，速乾性）
太描き用，細描き用，極細描き用の3種類がある。（米国製）

Markers
Markers have been in use for about 25 years and have now become an indispensible tool for product, graphic, interior, fashion and architectural design owing to their excellent functionability (markers can speed up sketch-work and are easy to handle owing to them being quick-drying).
Various markers are on the market at the moment, but the following are the ones that are most commonly used:

Copic
A twin-type marker combining both broad and slender nibs. This is a quick-dry marker that does not dissolve the copy toner. As alcohol has been used as the resolvent it gives off a bad odour, but this is relatively soft.

Pantone *(oil-base, quick-dry)*
There are three kinds of markers; for broad writing, slender writing and ultra-slender writing (made in the USA).

※**スピードライマーカー　ブロードチップ**（油性，速乾性，透明，太描き用）
チップの形がユニークにカットしてあり，細い線，中くらいの線，太い線，面のつぶし等，一本で自由な表現ができる。

※**スピードライマーカー　ピンポイント**（油性，速乾性，透明，細描き用）
ラインドローイングやディテールを描くのに最適。

※**BEROL EAGLECOLOR ART MARKER**（油性，速乾性）
細描きと太描きが一本についているので便利。（米国製）

※**ヌーベルデザインマーカー**（油性，速乾性）
太描きと細描きが一本についているので便利。

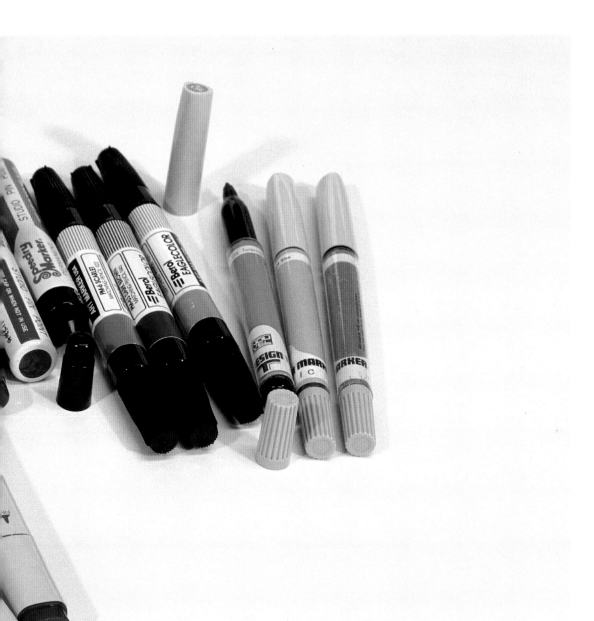

Broad-tip Speedry Marker (oil-base, transparent and broad-tip)
Owing to the unique shape and cut of the tip, a variety of line drawing from thin, though medium to thick can be freely expressed by this single marker. It can be used to paint out whole areas.

Pin-point Speedry Marker (oil-base, transparent and slender-tip)
The most suitable marker for line drawing and adding detail.

Berol Eaglecolor Art Marker (oil-base, quick-dry)
This is a handy marker as it combines nibs for slender and broad writing (made in the USA).

Nouvel Design Marker (oil-base, quick-dry)
This is a handy marker as it combines nibs for slender and broad writing.

❖ 液体マーカー

重ね折りしたティッシュペーパーやコットンパッドで，バックグラウンドなど幅広い面積のベタ塗りをスピーディに処理するとき用いる。

※ コピックバリオスインク（油性，透明）

混色は自由，コピーのトナーを溶かさない。

※ ホルベインイラストマーカー補充用インク（油性，速乾性）

❖ ベロールフローマスタークレンザー

粉状にしたパステルでバック処理をするときに欠かせない溶剤。又，液体マーカーをうすめたり，定規に付着した汚れ等を落とすのにも便利。

Liquid Marker
This is used to paint wide areas such as backgrounds using a double-folded tissue or cotton pad with speedy and rough strokes.

Copic Various Ink *(oil-base, transparent)*
Freely blendable and does not dissolve the copy toner.

Holbein Illustmarker Supplementary Ink *(oil-base, quick-dry)*

Berol Flomaster Cleaner
An indispensible resolvent when powder pastel is used for the background.
It is also handy for thinning down liquid markers and cleaning paint stains off rulers.

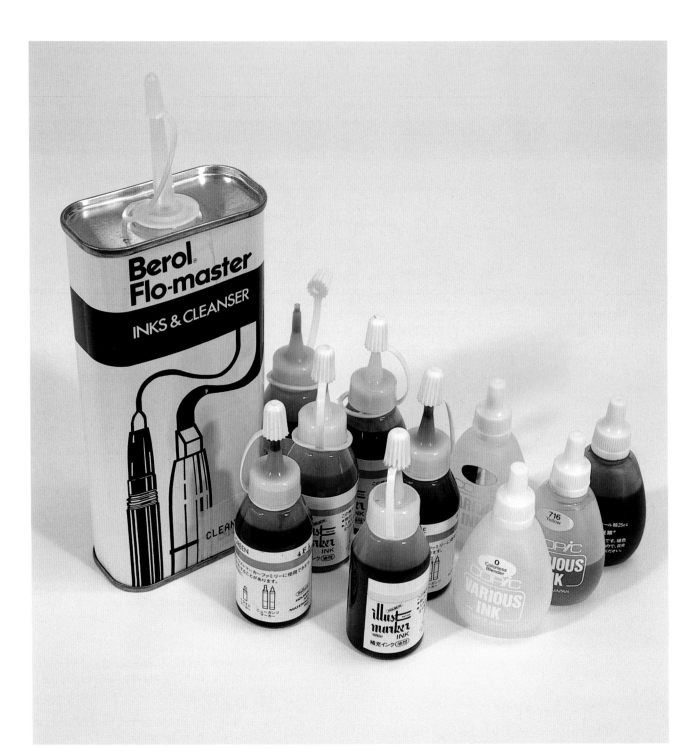

❖ ニューパステル96色セット （米国製）

角型のスティックになっているが，プロダクトデザインスケッチを描く場合などは，カッターナイフを使ってパステルを粉状にし，これを重ね折りしたネル，ティッシュペーパーにつけ画面を塗っていく。

❖ イージークリーナー （練りゴム）

ハイライトをつけたり，パステルを拭きとるのに便利。又，柔らかくて弾力性があるので，手で練って必要な太さにして使えるため，ディテールの描出や修正に便利である。

❖ 白ネル

柔らかな布地なので，パステルの塗りこみには欠かせない。

❖ デザインフィキサチーフ （スプレータイプ）

パステルなどを定着させるために使用する。

❖ BLAIR マーカー専用スプレーフィキサチーフ （米国製）

マーカーのテカリや塗りムラ防止用スプレーフィキサチーフ。マーカーで描いたスケッチに一吹きすると塗りムラ，テカリがとれ，仕上がりがきれい。

❖ 鉛筆型消しゴム

鉛筆タイプなのでディテールやハイライトライン，デザインラインを消して描出するのには便利。

❖ ベビーパウダー

パステルののりをよくするために使う。（粉状のパステルに若干混入する）

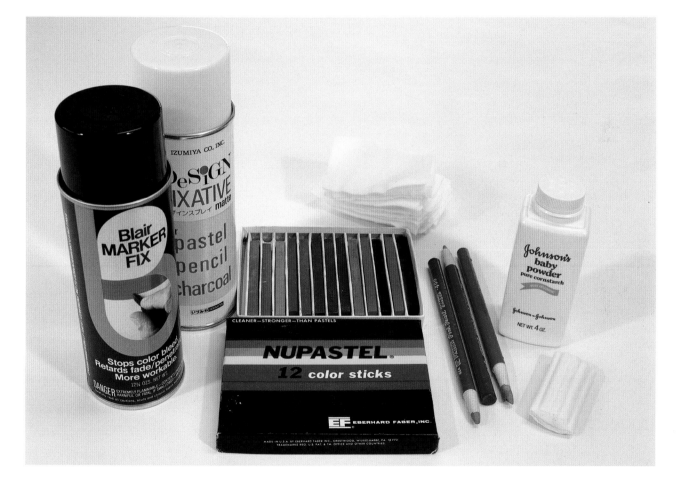

Nupastel *(made in the USA) 96-color set.*
These are square stick-type pastels, but when used for product design sketching they should be powdered down with a cutter-knife and applied with a double-folded tissue.

Easy Cleaner *(soft rubber)*
This is useful for adding highlights by wiping out pastel colors. It is also handy for detail drawing or repairs as it can be kneaded by hand to produce any shape desired owing to its soft and elastic features.

White Flannel
A very necessary piece of equipment for pastel painting owing to its soft texture.

Design Fixative *(spray type)*
Used to fix pastels onto the picture.

Blair Spray Fixative for marker use *(made in the USA)*
This is a spray fixative used to prevent glossing or uneven coverage for markers. One spray of this fixative can irradicate uneven shading and glossy areas and improve the overall picture.

Penciltype Eraser
Owing to its pencil-like features, this eraser is handy for depicting highlight and design lines by erasing them.

Baby Powder
This is used to help pastels spread well (a small amount should be added to the powdered pastel).

❖ トレーシングペーパー

透写し易いのでスケッチの下描き等には欠かせない紙である。又，パステルを粉状にするベースに使ったり，マスキングテープと併用してマスキングに使うなど用途は広い。

❖ スケッチ用紙

❖ PM パッドホワイト

マーカー，パステル用に開発されたレイアウトペーパーで，適度の粗さ，硬さがあるため，マーカー，パステルののりがよい。又，白色の半透明紙なので透写に適している。

❖ ヴェラム紙 （いづみや VR パッド・米国ヴィンセント社製）

ヴェラム紙は透明度がすぐれているので透写がし易いうえ，マーカー，パステルの裏面処理で，微妙なハーフトーンの表現も簡単にできるので，滑らかな曲面を描くには最適の用紙といえる。

❖ ジアゾ感光紙 （青写真用の感光紙）

詳しくはスケッチ作例"マシニングセンターを描く"の項を参照のこと。

Tracing Paper
This is an indispensible article for drawing sketches and for ease of tracing. It can also be used for different functions such as a base on which pastel can be powdered or in combination with masking tape.
Sketch Pad
PM Pad White
As this paper was specially developed for marker and pastel work, these materials will spread well on it. It features a moderate courseness and stiffness.
Vellum Paper *(Izumiya VR Pad. US Vincent)*
This is a most suitable paper for drawing gentle curved surfaces as it makes tracing easy. Delicate half-tones can also be expressed well on it by applying markers and pastels from the background of the paper in order to take advantage of its high degree of transparency.
Diazotized Paper *(bluprint paper)*
For details, see the sketch "The Drawing of a Machine Center".

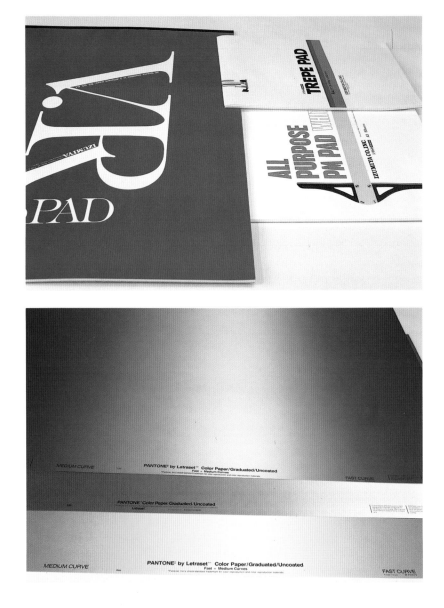

❖ パントンカラーペーパー （グラデーション付き，米国製）

パントンカラーペーパーのバックグラウンド付きは，色彩，グラデーションが美しくプリントされているので，ムードが要求されるスケッチ（ガラス器，宝石関係等のデザインスケッチではバックグラウンドの表現は欠かせない）表現には最適といえる。

Pantone Gradated Tone Paper *(made in the USA)*
This paper is suitable for those sketches that need to express mood (background expression is indispensible for design sketches of glasswear and jwelry). Colors and gradating tones will come out beautifully on this paper.

✥アクリル直定規 (長さ40センチ，アクリル製，溝付き)

下描き，ラインドローイング，溝引きをする時に使用する。

✥楕円定規

透明塩化ビニール製で，円のパースペクティブ表現には欠かせない定規。投影角15°から5°おきに60°まで20枚組が使いやすい。

✥カーブ定規

曲線の表現には欠かせない定規。

❋いづみやんカーブC型，黄色透明で10枚組

❋レンダリングカーブ，透明でスケール入り，6枚組

Acrylic Straight Ruler *(40cm long, acrylic, grooved)*
Used for sketching, line drawing and groove line drawing.
Oval Ruler
This is made of clear vinyl chloride and is indispensible for expressing curved perspective drawings. Projection angles are available from 15° to 60° with 5° progressions. A set of twenty is recommended.
Curved Ruler
Indispensible rulers for drawing curved lines are:
 Izumiyan curved C-type. Clear-yellow coloring.
 Rendering curve. Clear with scale measuring printed. Six in one set.

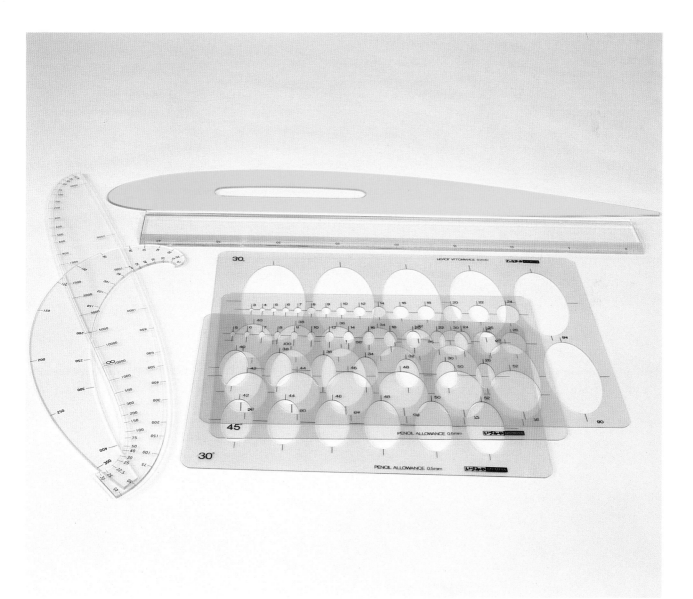

❖ ベロールイーグルカラーペンシル

芯が柔らかいので，マーカーで描いた上からでもハッキリと色がのり，マーカースケッチ等の最終仕上げ段階近くのタッチアップには欠かせない。

❖ 水性黒サインペン (NIKKO FINEPOINT SYSTEM 0.2〜0.5)

スケッチのラインドローイングや下描きなどに使う。

❖ 黒，赤ボールペン (細)

スケッチのラインドローイングに使う。サインペンより細い線描きにはボールペンのほうがよい。

❖ 普通鉛筆 (HB〜2H)

スケッチ下描き，ラインドローイング等に。

❖ バニーマスキングテープ

半透明紙，幅12ミリ，20ミリ，30ミリ使用。

Berol Eagle Color Pencils
Owing to soft lead being used, the color spreads well on top of marker color. They are therefore very valuable tools for the final touch-ups just before the finishing stages of a marker sketch.

Water Color Felt-tip Pen *(Nikko Finepoint System 0.2~ 0.5)*
These are used for line drawing and underlining on sketches.

Regular Pencils *(HB~2H)*
Used for sketching and line drawing.

Black and Red Ball-point Pens *(slender point)*
These are used for sketch line drawing. Ball-point pens are preferable over flet-tip pens as they produce thinner lines.

Bonny Masking Tape
10mm, 20mm and 30mm width semi-transparent masking tape was used.

❖溝引きガラス棒

❖陶製の白絵具皿

油性の液体マーカーを使用するため，樹脂製の絵具皿はさけること。

❖ポスターカラー

チューブタイプの白と黒。

❖カラースティック

絵具にカラースティック数滴を混ぜて使用すると，弾水性のあるものにもスムーズに描け，絵具もよくのる。

❖筆

面相1号〜4号，平筆1号。面相は主にスケッチ最終仕上げ段階のタッチアップで使用する。

❖ティッシュペーパー

パステルの塗りこみに使ったり，定規類などの汚れを拭いたり，その用途は広い。

❖ナイフ（NTカッター）

Glass Grooving Stick

White Ceramic Palette
Vegetable tallow palettes should be avoided as oil-based liquid markers are used here.

Poster Color
Black and white tube-types.

Color Stick
The blending of a few drops of color stick with the paint helps it spread well on water-repellent surfaces.

Brushes
Features No. 1 ~ No. 4, flat brush No. 1. Feature brushes are mainly used to add touch-ups on the final finishing stages of a sketch.

Tissue Paper
Tissue is used for various pruposes such as for painting in pastel and for wiping excess paint off rulers.

Knife *(NT cutter)*

Ａ３サイズレイアウトペーパー（ＰＭパッド白） *A3-size layout paper (white PM pad)*

コンセプトスケッチ
作例Ａ

Example A of
a Concept Sketch

①レイアウトペーパーに，黒の水性サインペン，ボールペンでラインドローイングする。

(1) Do the line drawing in black water-color felt-tip pen and ball-point pen on the layout paper.

②バックグラウンドの上下をマスキングする。重ね折りしたティッシュペーパーを金属クリップで挟み，これに青系の液体マーカーをふくませ，縦のストロークでバックグラウンドと本体の色を一緒に処理する。
注）バックグラウンドと本体の色の処理は簡潔，スピーディに行う。

(2) Apply masking to the top and bottom parts of the background. Use a metal clip to firmly grip a double-folded tissue and dip this in a blue tint liquid marker to paint in both the background and the body.
NB: The coloring of the background and body should be carried out concisely and speedily.

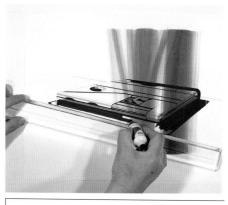

④黒のマーカーでキャストシャドウをいれ，画面全体を引きしめる。

(4) Add the shadow in black marker to brace up the entire picture.

⑤マーカー処理終了。

(5) The marker work complete.

The Point of Technique

●本体の色や明暗の調子とバックグラウンドを一緒に，マーカーやパステル等を使ってラフタッチで処理する方法はコンセプトスケッチには最適であろう。
この手法は早く描け，強いストロークで処理されたバックグラウンドはスケッチを軽快にみせる。

The method of using markers and pastels to work on the value of color on the body and background in a rough-touch method is most suitable for concept sketching.
The advantages of using this method are; shortening the actual drawing time and making the sketch look light due to the strong stroke work of the background.

A Stationery Box

③バックグラウンド処理が終わったらマスキングをはずし，本体のディテールをマーカーで描く。

(3) Remove the masking after the background has been completed and then draw in the body detail with markers.

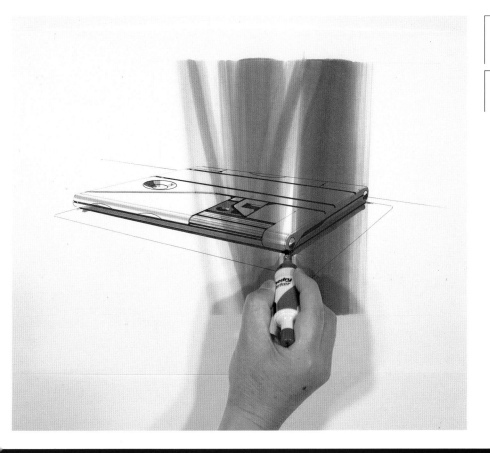

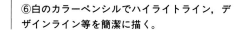

⑥白のカラーペンシルでハイライトライン，デザインライン等を簡潔に描く。

(6) Draw the highlight lines and design lines concisely in white pencil.

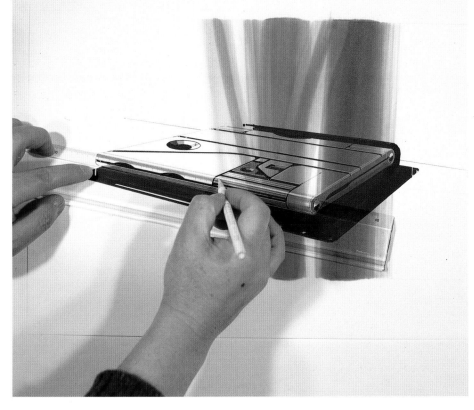

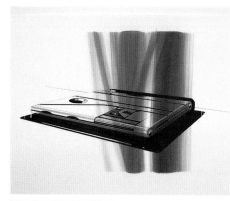

⑦白のカラーペンシルでハイライトライン，デ
ザインライン等がはいったスケッチ。

*(7) The sketch with the highlight lines and
design lines in white pencil.*

⑧白のポスターカラーでハイライトライン，デ
ザインラインなどのタッチアップをする。

*(8) Add the touch-ups by drawing in the high-
light lines and design lines with white poster
color.*

⑨完成したステーショナリーボックスのコンセ
プトスケッチ。

*(9) The completed concept sketch of the sta-
tionery box.*

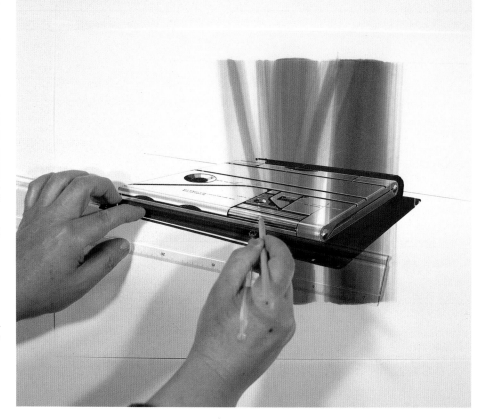

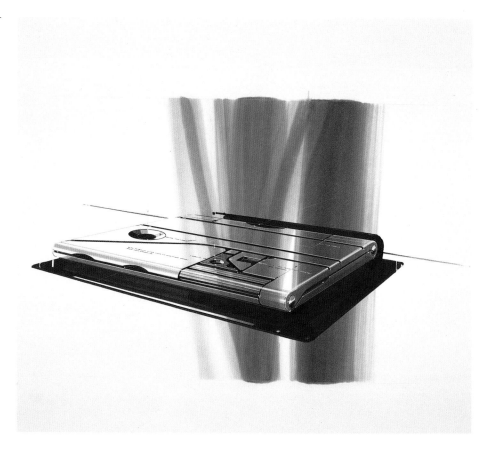

白のカラーペンシルによるデザインライン
The design lines in white pencil.

バックグラウンドと本体の色を一緒に処理する
バックグラウンドの上下をマスキングし，重ね折りしたティッシュペーパーを金属クリップで挟み，これに青系の液体マーカーをしみこませ，たてのストロークで塗る
注）バックグラウンド処理は簡潔に
Use the same color to paint the background and the body of the machine.

レイアウトペーパーに黒水性サインペン，ボールペンでラインドローイングする
Use black water-color felt-tip pen or ball-point pen for the line drawing.

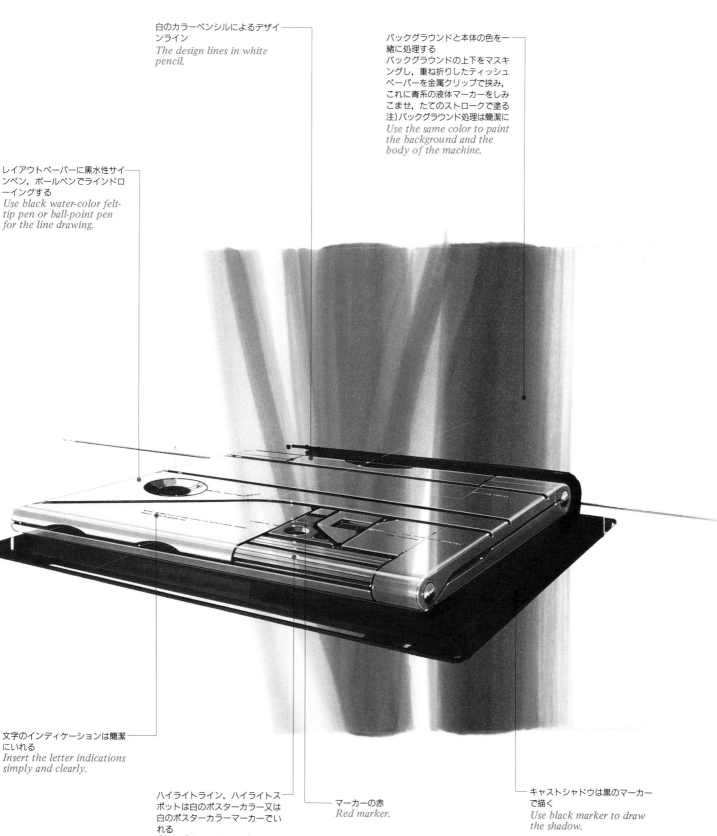

文字のインディケーションは簡潔にいれる
Insert the letter indications simply and clearly.

ハイライトライン，ハイライトスポットは白のポスターカラー又は白のポスターカラーマーカーでいれる
Use white poster color or poster color marker to insert the highlight lines and spots.

マーカーの赤
Red marker.

キャストシャドウは黒のマーカーで描く
Use black marker to draw the shadow.

コンセプトスケッチ
作例B
Example B of
a Concept Sketch

A 3 サイズレイアウトペーパー
（ＰＭパッド白）
A3-size layout paper (white PM pad)

①バックグラウンドの上下をマスキングし，グレイマーカーNo. 4 〜No. 6 を使い，縦方向のストロークで簡潔に描く。

(1) Apply masking to the top and bottom of the background. Use grey marker No. 4 ~ No. 6 and work with verticle strokes.

②黒等の細描きマーカーで本体のディテール，キャストシャドウ等を描き，マーカー処理終了。

(2) Draw in the details and shadow in thin black marker to complete the marker work.

③白のカラーペンシルでハイライトライン，デザインライン等をいれる。

(3) Add the highlight lines and design lines in white pencil.

④白のポスターカラーで，ハイライトライン，デザインラインなどをタッチアップして完成。

(4) Add the touch-ups to the highlight lines and design lines in white poster color to complete.

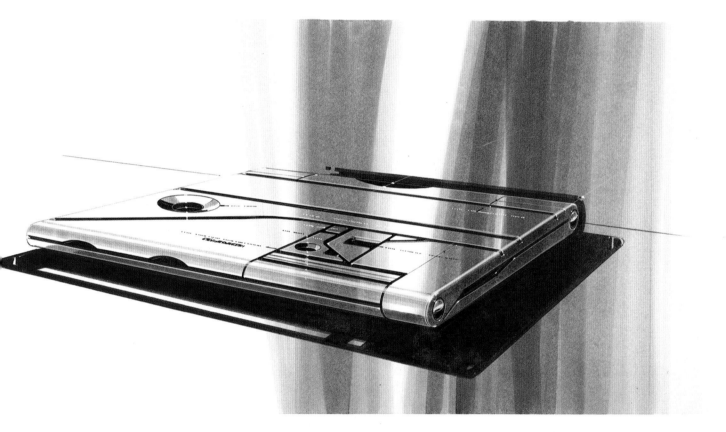

⑤完成したステーショナリーボックスのコンセ
プトスケッチ。

(5) The completed concept sketch of the sta-
tionery box.

コンセプトスケッチ
作例C
Example C of a Concept Sketch

A 3 サイズコピー紙(線描きコピー済)
A3-size copy paper (line copy finish)

①コピー済みの線描きスケッチ。
黒等のサインペンで基本的なラインドローイングし、複写機にかけコピーする。

(1) The sketch with the completed line copy. Make the basic line drawing in black felt-tip pen and copy it with a copy machine.

③コピックマーカーを使い本体のディテールを描いていく。

(3) Use a Copic marker to draw in the body detail.

②バックグラウンドの上下をマスキングし、重ね折りしたティッシュペーパーを金属クリップで挟み、これにオレンジ系コピックマーカー液をふくませ、簡潔なストロークでバックグラウンド処理をする。
備考)コピックマーカーはコピーのトナーを溶かさないため、コピーしたスケッチ等に着色するには適している。

(2) Apply masking to the top and bottom of the background. Using a double-folded tissue gripped firmly in a metal clip, work on the background with consise strokes with the tissue dipped in an orange Copic marker solution.
NB: Copic markers are suitable for copied sketches as they do not dissolve the copy toner.

④コピックマーカーによるマーカー処理終了。

(4) The Copic marker work is complete.

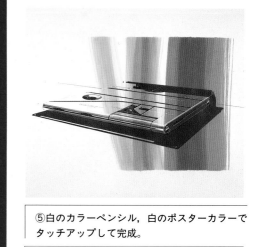

⑤白のカラーペンシル、白のポスターカラーでタッチアップして完成。

(5) Add the touch-ups with white pencil and white poster color to complete.

⑥完成したステーショナリーボックスのコンセプトスケッチ。

(6) The complete concept sketch of the stationery box.

フィッシングタックル コンセプトスケッチ 作例

A 3 サイズレイアウトペーパー（PMパッド白） *A3-size layout paper (white PM pad)*

FISHING TACKLE GRAPHICMECHAMISM

GR-92.0

レイアウトペーパーに黒の水性サインペン，ボールペン，カラーペンシルでラインドローイングし，マーカーで簡潔に陰影等を表現してある。ラインドローイングの60％位はフリーハンドで，40％はスイープ等の定規を使って描いた。

Black water-color felt-tip pen, ball-point pen and colored pencils were used to do the line drawing on the layout paper, and the shadows were then briefly expressed in markers.
60% of the line drawing was done by hand, and the rest with the use of such rulers as the sweep.

An Example of a Fishing Tackle Concept Sketch

①カーブ定規，スイープを使い黒水性サインペン0.2㎜で簡潔にラインドローイングする。
備考）スケッチのサイズは実物大とした。

(1) Use a curved ruler and sweep to draw in brief lines in black water-color felt-tip pen (0.2mm).
NB: The actual size of the sketch is used.

②完成した線描きスケッチ。
注）線描きの段階ではディテール表現はしない。

(2) The complete line-drawn sketch.
NB: It is not necessary to include the details at this stage of the line drawing.

③クールグレイNo.5〜No.8を使ってはみだしを気にしないで，ラフなストロークで塗る。
多少のはみだしはあとのバック処理の時，黒マーカーで塗りつぶされクリアになる。

(3) Using cool-grey No. 5 ~ No. 8, paint in rough strokes. It does not matter at this point if the markers go over the lines as this will be painted over in black marker in the background stage.

④マーカー処理が終わったスケッチ。

(4) The sketch with all marker work complete.

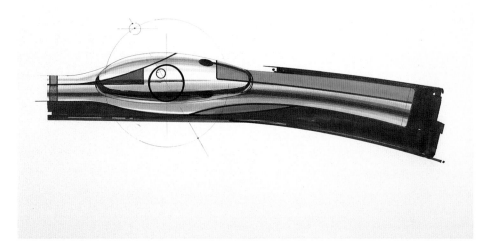

⑤白のインスタントレタリングをはりこむ。

(5) Stick on white instant lettering.

⑥カーブ定規，スイープを使い白のカラーペンシルでデザインライン，ハイライトライン等を描いていく。

(6) Use a curved ruler and sweep to draw in the highlight lines and design lines in white pencil.

⑦白のポスターカラーで簡潔にハイライトスポットをいれて完成。

(7) Add the highlight spots concisely with white poster color.

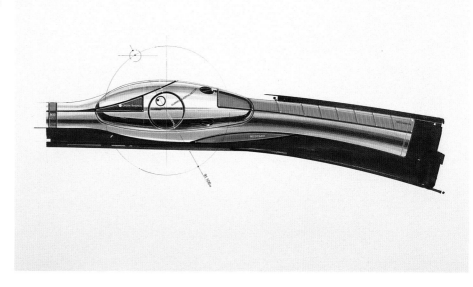

The Point of Technique

●コンセプトスケッチにハイライトスポット，ハイライトラインをいれるには，白のポスターカラーマーカー（スティック状，丸芯で筆記幅1.0㎜位）が便利である。
ポスターカラーを溶いたり，水，絵具皿，筆洗器を用意したりの手間が省けるので，早く描くコンセプトスケッチのタッチアップにはもってこいの画材といえる。

White poster color marker (stick-type with a round lead measuring approximately 1.0mm) is convenient for adding the highlight spots and highlight lines onto concept sketches.
As there is no necessity to prepare painting materials such as water, pallet, brush-washer, etc., it is an ideal painting material for quick touch-ups during the drawing concept.

⑧完成したフィッシングタックルのコンセプトスケッチ。

(8) The completed concept sketch of the fishing tackle.

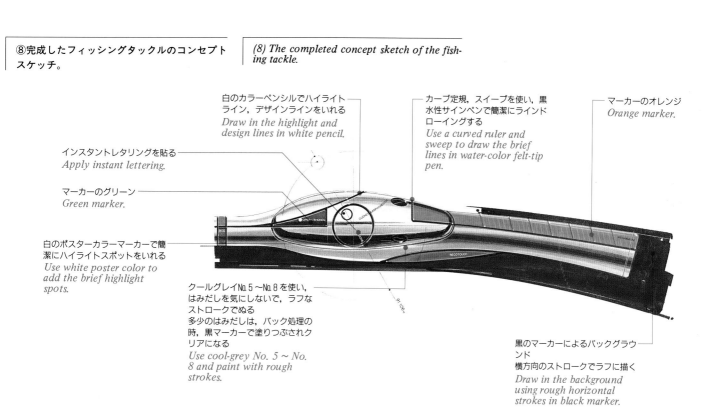

白のカラーペンシルでハイライトライン，デザインラインをいれる
Draw in the highlight and design lines in white pencil.

カーブ定規，スイープを使い，黒水性サインペンで簡潔にラインドローイングする
Use a curved ruler and sweep to draw the brief lines in water-color felt-tip pen.

マーカーのオレンジ
Orange marker.

インスタントレタリングを貼る
Apply instant lettering.

マーカーのグリーン
Green marker.

白のポスターカラーマーカーで簡潔にハイライトスポットをいれる
Use white poster color to add the brief highlight spots.

クールグレイNo.5～No.8を使い，はみだしを気にしないで，ラフなストロークでぬる
多少のはみだしは，バック処理の時，黒マーカーで塗りつぶされクリアになる
Use cool-grey No. 5 ~ No. 8 and paint with rough strokes.

黒のマーカーによるバックグラウンド
横方向のストロークでラフに描く
Draw in the background using rough horizontal strokes in black marker.

A3サイズレイアウトペーパー（PMパッド白）*A3-size layout paper (white PM pad)*

作例A Example A

粉状にした青系パステルを重ね折りしたティッシュペーパーにつけて塗り，その上から粉状の黒のパステル少量を指につけぼかし塗りする
注）パステル処理は簡潔に
Paint with a double-folded tissue paper dipped in a blue shade powder pastel and then apply a small amount of black pastel with ones finger to shade off.
NB: Simplify the pastel work.

マーカーのクールグレイNo.5〜No.7と黒を重ね塗りして，グラデーションをつける
Paint the grey marker No. 5 ～ No. 7 and the black overlapping each other to add gradation.

文字のインディケーションは白のポスターカラーマーカーで簡潔にいれる
Place the letter indications clearly in white poster marker.

黒のマーカーで塗りつぶす
Paint out with black marker.

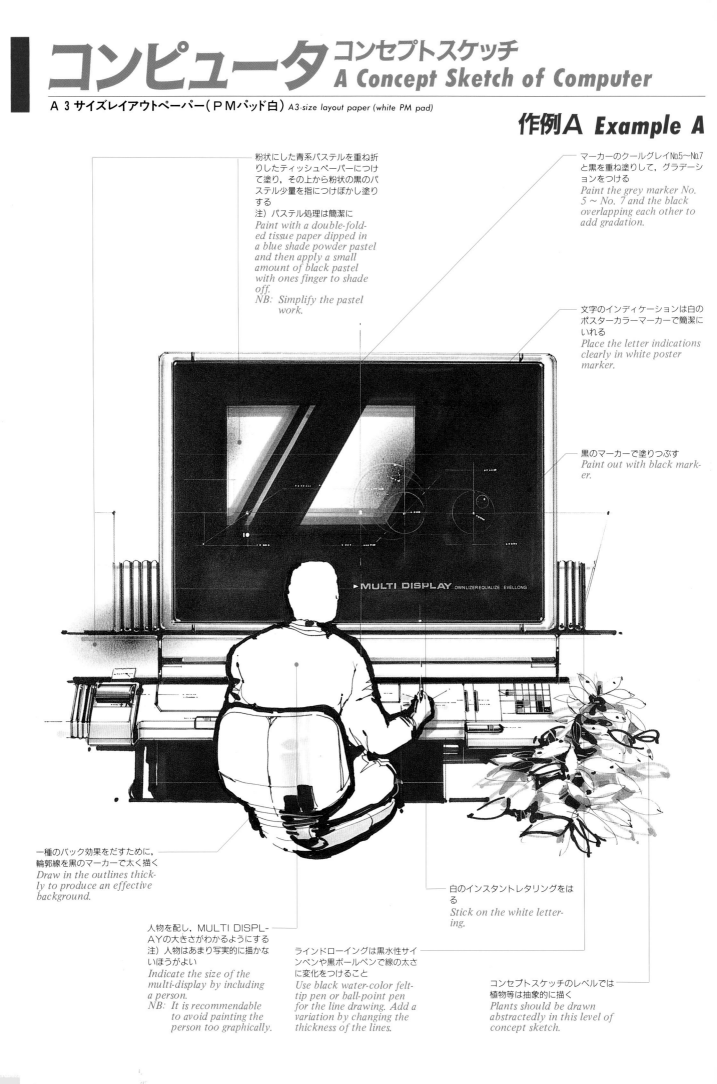

一種のバック効果をだすために，輪郭線を黒のマーカーで太く描く
Draw in the outlines thickly to produce an effective background.

白のインスタントレタリングをはる
Stick on the white lettering.

人物を配し，MULTI DISPLAYの大きさがわかるようにする
注）人物はあまり写実的に描かないほうがよい
Indicate the size of the multi-display by including a person.
NB: It is recommendable to avoid painting the person too graphically.

ラインドローイングは黒水性サインペンや黒ボールペンで線の太さに変化をつけること
Use black water-color felt-tip pen or ball-point pen for the line drawing. Add a variation by changing the thickness of the lines.

コンセプトスケッチのレベルでは植物等は抽象的に描く
Plants should be drawn abstractedly in this level of concept sketch.

作例B **Example B**

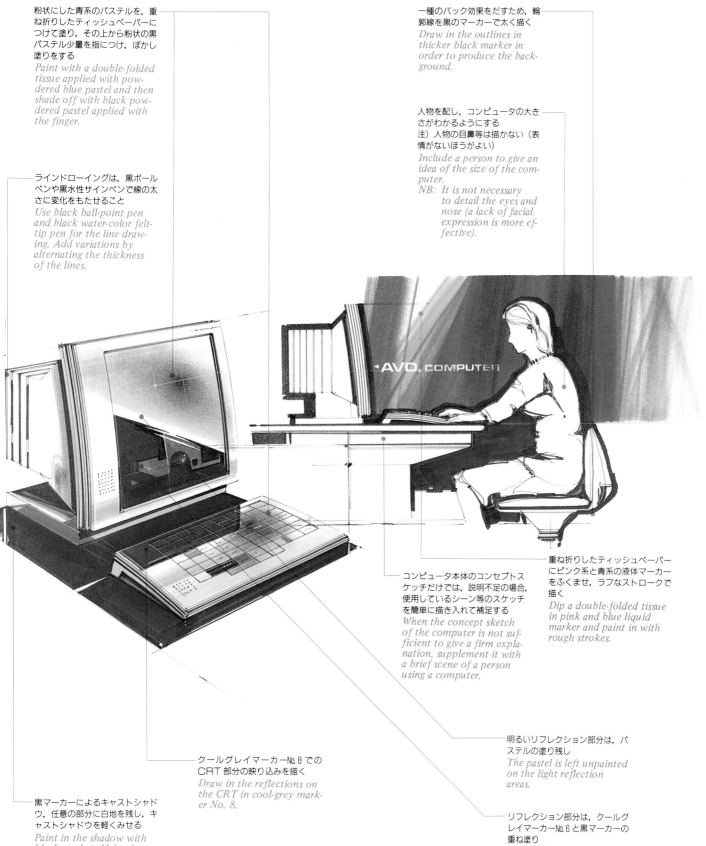

粉状にした青系のパステルを，重ね折りしたティッシュペーパーにつけて塗り，その上から粉状の黒パステル少量を指につけ，ぼかし塗りをする
Paint with a double-folded tissue applied with powdered blue pastel and then shade off with black powdered pastel applied with the finger.

ラインドローイングは，黒ボールペンや黒水性サインペンで線の太さに変化をもたせること
Use black ball-point pen and black water-color felt-tip pen for the line drawing. Add variations by alternating the thickness of the lines.

一種のバック効果をだすため，輪郭線を黒のマーカーで太く描く
Draw in the outlines in thicker black marker in order to produce the background.

人物を配し，コンピュータの大きさがわかるようにする
注）人物の目鼻等は描かない（表情がないほうがよい）
Include a person to give an idea of the size of the computer.
NB: It is not necessary to detail the eyes and nose (a lack of facial expression is more effective).

重ね折りしたティッシュペーパーにピンク系と青系の液体マーカーをふくませ，ラフなストロークで描く
Dip a double-folded tissue in pink and blue liquid marker and paint in with rough strokes.

コンピュータ本体のコンセプトスケッチだけでは，説明不足の場合，使用しているシーン等のスケッチを簡単に描き入れて補足する
When the concept sketch of the computer is not sufficient to give a firm explanation, supplement it with a brief scene of a person using a computer.

明るいリフレクション部分は，パステルの塗り残し
The pastel is left unpainted on the light reflection areas.

リフレクション部分は，クールグレイマーカーNo.6と黒マーカーの重ね塗り
Use cool-grey marker No. 6 and black to paint the reflections by overlapping the two colors.

クールグレイマーカーNo.8でのCRT部分の映り込みを描く
Draw in the reflections on the CRT in cool-grey marker No. 8.

黒マーカーによるキャストシャドウ，任意の部分に白地を残し，キャストシャドウを軽くみせる
Paint in the shadow with black marker. Make the shadow seem lighter by leaving the white ground in one place.

クリーナー コンセプトスケッチ
A Concept Sketch of a Cleaner

Ａ３サイズレイアウトペーパー（ＰＭパッド白） *A3-size layout paper (white PM pad)*

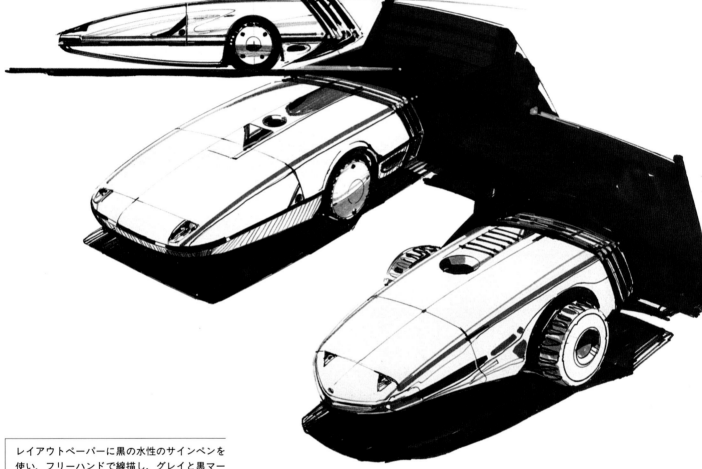

レイアウトペーパーに黒の水性のサインペンを
使い，フリーハンドで線描し，グレイと黒マー
カーで，簡潔にキャストシャドウ，バックグラ
ウンドを描く。
ハイライトスポットなどは白のポスターカラー
で極めて簡潔にいれる。

Use a black water-color felt-tip pen to draw
in the lines on the layout peper by hand.
Change to grey and black markers to draw in
the shadows and background concisely.
Add the highlight spots carefully in white
poster color.

スケッチ作例

SKETCH DEMONSTRATION

Ａ３サイズパントンカラーペーパー（グラデーション付） A3-size color paper (with gradation)

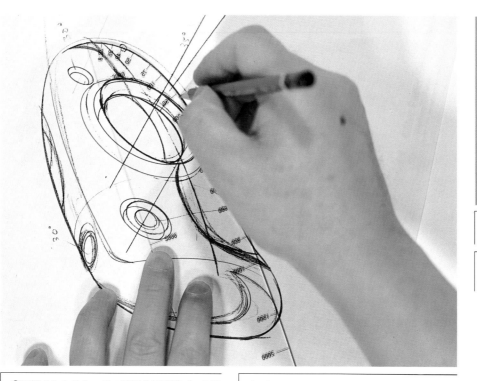

②下描きスケッチをはずす。
薄く転写されたカメラのデザインライン。

(2) Remove the rough copy of the sketch. The faintly transfered design lines of the camera.

①下描きしたスケッチの裏面を黒鉛筆（ＨＢ程度）で塗りつぶし，これをパントンカラーペーパー（グレイのバックグラウンド付）の上に重ね，ボールペン又は硬質鉛筆でデザインライン，ディテール等をなぞり描きし，転写する。

(1) Smear in the background of the sketch in black pencil (HB) and place this on top of the color paper (with a grey background) in order to transfer the sketch by tracing the design lines and details in with a ball-point pen or hard pencil.

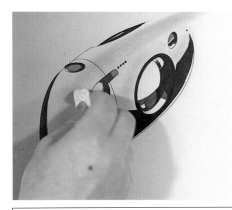

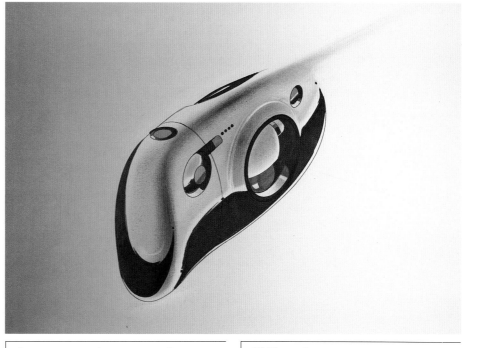

⑦粉状にした赤系パステルを，重ね折りしたネルにつけ，本体の面を塗る。

(7) Apply a red shade powdered pastel to a double-folded tissue to raise the body of the camera.

⑧リフレクション部分，明るい面等はパステルを塗り残しておくか，あとで消しゴムや練りゴムでパステルを拭きとる。
スプレーフィキサチーフでパステルを定着してパステルワーク終了。

(8) The reflection or lighter parts should be left unpainted or wiped out with an eraser or soft rubber. Apply the fixative spray to set and finish the pastel work.

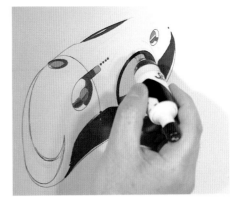

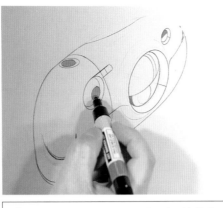

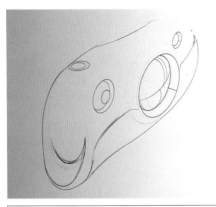

③黒のボールペンでデザインライン，リフレクションのラインドローイングをする。
完成したラインドローイング。

(3) Draw in the design lines and reflections in black ball-point pen. The line drawing complete.

④色マーカーを使ってシャッターなどを描く。

(4) Draw in the shutter in color marker.

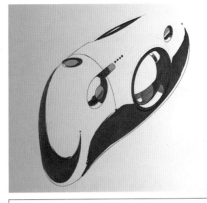

⑥マーカー処理が終わったスケッチ。

(6) The sketch with the marker work complete.

⑨白のカラーペンシルで，デザインライン，ハイライトライン，ディテールを描く。

(9) Draw in the highlight lines, the design lines and the details in white pencil.

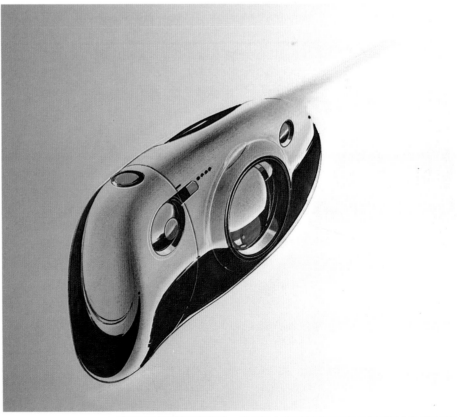

⑩白のカラーペンシルによってハイライト，デザインライン，ディテール等の表現されたスケッチ。

(10) The sketch with the highlight lines, the design lines and the details drawn in white pencil.

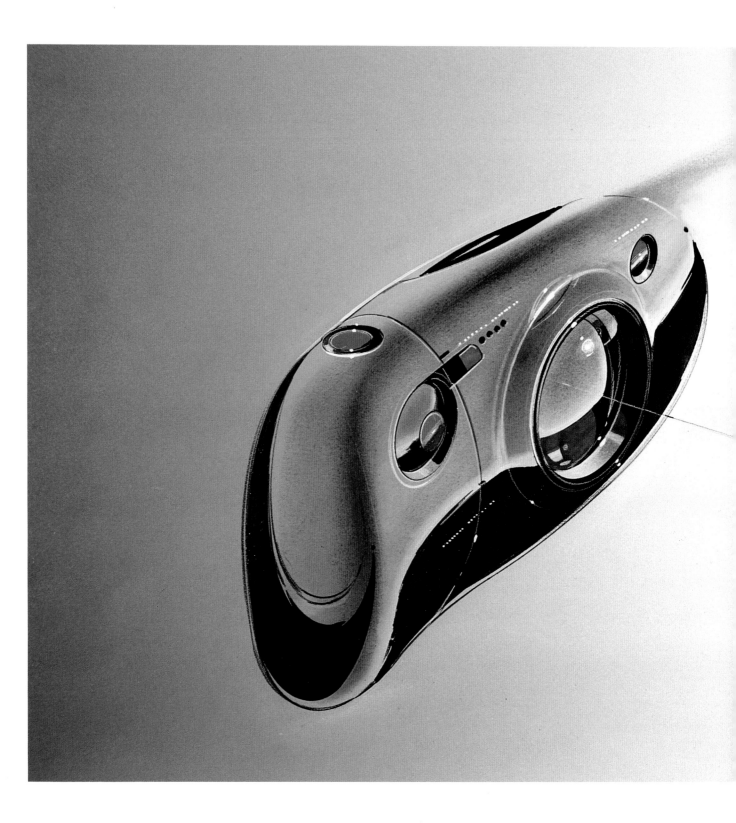

⑪白のポスターカラーでディテール，デザイン
ライン，ハイライトをいれて完成する。
比較的ラフなタッチで描いてあるが，バックグ
ラウンド付のスケッチ用紙を使用したため，ア
トラクティブなスケッチとなった。

*(11) Add white poster color to the highlight
lines, design lines and details to complete the
work. Although it is only a rough sketch,
the use of the sketch paper with its own back-
ground has turned it into a very attractive
work.*

粉状の赤系パステルを，重ね折り
にしたネルにつけ，本体の面を塗る
*Apply a red shade of
powder pastel to a double-
folded flannel to draw the
body.*

スケッチ用紙はパントンカラーペ
ーパー（グレイのバックグラウン
ド付）を使用
*Use Panton color paper for
the sketch paper (with a
grey background).*

白のポスターカラーマーカーでハ
イライトスポットをいれる
*Draw in the highlight spots
in white poster color.*

楕円定規を使い，白のカラーペン
シルで描く
*Use an elliptical ruler and
white pencil to draw.*

黒のマーカーでリフレクションを
描く
*Use black marker to draw
in the reflection.*

黒のボールペンでデザインライン，
リフレクションの線描きをする
*Draw the design and reflec-
tion lines in black ball-
point pen.*

青紫系パステルのぼかし塗りでス
カイトーンを表現
*Shade off the blue-purple
pastel to express the sky-
tone.*

テレフォンを描く *Drawing a Telephone*

B 3 サイズレイアウトペーパー（PM パッド白）*B3-size layout paper (white PM pad)*

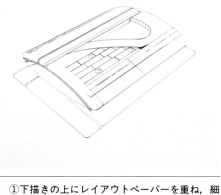

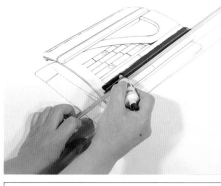

①下描きの上にレイアウトペーパーを重ね，細い線は黒ボールペン，太い線は黒水性サインペン（0.2〜0.3㎜程度）でラインドローイングする。

(1) Place a sheet of layout paper on top of the sketch and then trace the thin lines with a black ball-point pen and the thick lines with a black water-color felt-tip pen (0.2 ~ 0.3mm).

②クールグレイのNo. 5 〜No.10でリフレクション，ディテールを描いていく。
細部は細描きマーカーを使って描く。

(2) Fill in the reflections and details with cool-grey colors between No. 5 and No. 10. Use a thin marker for filling in the small sections.

③任意の色マーカーでキーボード部分を描く。

(3) Draw in the keyboard with any color marker.

⑦ハイライトライン，デザインラインなどは直定規，カーブ定規を使い，鉛筆型消しゴムで入れていく。（パステルを拭きとっていく）
スプレーフィキサチーフでパステルを定着してパステル処理終了。

(7) Fill in the highlight and design lines with the use of a pencil-style eraser and a straight or curved ruler (rub out the pastel).
Apply the spray fixative to complete the pastel work.

⑧白のカラーペンシルで，ハイライトライン，デザインライン，ディテールを描く。

(8) Draw in the highlight lines, the design lines and the details with a white color pencil.

④黒マーカーでキャストシャドウ等を入れ，マーカー処理終了。

(4) Fill in the shadow with a black marker to complete the marker process.

⑤パステルワークにはいる。
重ね折りしたネル又はティッシュペーパーに，粉状にした青系パステルをつけてリフレクション部分を描く。

(5) Commence the pastel work.
Draw in the reflection with the use of a double-folded flannel or tissue paper applied with a powdered blue shade pastel.

⑥粉状にした黒パステル（黒50％，青50％で混ぜ合わせる）を，重ね折りしたネル又はティッシュペーパーにつけて本体の面を塗っていく。明るいリフレクション部分等は塗り残しておく。

(6) Fill in the main body of the telephone with powdered black pastel (a 50/50 blend of black and blue pastel) using the double folded flannel or tissue.
The section requiring the light reflection should be left unpainted.

⑨白のポスターカラーでハイライトライン，デザインライン，ディテールを描き完成。デザインライン，ハイライトラインの直線部分は溝引きを使って入れる。

(9) Using white poster color paint in the highlight lines, the design lines and the details to complete this section. A grooved-ruler should be used to draw the straight highlight and design lines.

⑩完成したテレフォンのスケッチ。（バックグラウンドは別紙に描き，完成したスケッチをカットアウトし，これに貼る）

(10) The complete sketch of the telephone.
(The background should be drawn on separate paper and then stuck onto the sketch paper after being cut out).

⑫完成したスケッチ⑩をカットアウトし，別紙（バックグラウンドA・B・C）に貼る。ここでは，バックグラウンドAに貼った。

(12) Cut out the complete sketch indicated in No. 10 and then stick it onto a separate piece of paper (background A, B or C). In this case background A has been chosen.

The Point of Technique

⑪別のレイアウトペーパーにバックグラウンド（タイプA，B，C）を描く。

(11) Draw the background on a separate piece of layout paper (draw in the following types of A, B and C).

●A・レイアウトペーパーの必要部分をマスキングし，溶剤（フローマスタークレンザー）でぬらし，乾かないうちに黄，青，赤系等の液体マーカーを任意に落として描く。
偶然の効果をそのまま残しておく。

(A) Apply the masking tape where needed and then dip in the solution (containing Flo Master Cleanser). Before it dries drop and draw the color markers yellow, blue and red anywhere onto the paper.

●B・レイアウトペーパーの必要部分をマスキングし，黄色系の液体マーカー又はマーカーを塗る。次に，硬めの歯ブラシにダークグレイの液体マーカーをふくませ，金網の上で軽くこすって画面にふりかけ完成する。

(B) Firstly, apply the masking tape to the section of the layout paper where needed and then paint on the yellow shade liquid marker. Secondly, apply some dark grey liquid marker to a hard-hair toothbrush and then spatter the color onto the surface by scrubbing the toothbrush across a wire net to complete this section.

●C・レイアウトペーパーの必要部分をマスキングし，重ね折りしたティッシュペーパーに，溶剤（フローマスタークレンザー）と黄，赤系などの液体マーカーを含ませ，軽くたたいて表現する。

(C) Apply the masking tape where necessary and then tap a double-folded tissue dipped in a solution (containing Flo Master Cleanser) and the red and yellow shade liquid markers gently across the surface for added expression.

⑬完成したテレフォンのスケッチ。

(13) The complete sketch of the telephone.

粉状にした黒パステル（黒50％,
青系50％を混ぜ合わせる）を，重
ね折りしたネル又はティッシュペ
ーパーにつけ，滑らかな本体の面
を描く
*A doubly folded flannel
or tissue applied with
powdered black pastel
(50/50 blend of black and
blue) is used to paint the
smooth surface of the
telephone.*

明るいリフレクションの部分は,
鉛筆型消しゴムでパステルを拭き
とり表現する
*The light reflection section
is expressed by rubbing the
pastel with a pencil-type
eraser.*

バック処理する部分を溶剤（フロ
ーマスタークレンザー）で濡らし,
乾かないうちに液体マーカーを任
意に落として描く
（偶然の効果を残しておく）
*Dip the section which
needs the background
work in a solution
(containing Flo Master
Cleanser) and create pat-
terns upon it by splashing
liquid marker color on it
before it dries.
(The natural effect is left).*

ラインドローイングは，黒ボール
ペンや黒水性サインペンで
*Use a black ball-point pen
or a black water-color flet-
tip pen for the line drawing.*

鉛筆型消しゴムでパステルを拭き
とった後，白のポスターカラーで
ハイライトラインを入れる
*Draw in the highlight lines
with a white pencil after
the pastel has been rubbed
out with a pencil-type
eraser.*

白のカラーペンシルによるデザイ
ンライン
*The design lines in white
colored pencil.*

完成した本体のスケッチはカット
アウトして，バック処理をした他
のレイアウトペーパーに貼りこむ
*The complete sketch of the
telephone is cut out and
stuck onto the other lay-
out paper which contains
the completed background
work.*

白のポスターカラーで文字のイン
ディケーションを小さく簡潔にい
れる
*Draw in the indications
with white poster color
small and simply.*

黒のリフレクション部分は黒サイ
ンペンと黒細描きマーカーで描く
*Draw in the black reflec-
tion with a black felt-tip
pen and a black marker.*

黒のマーカーによるキャストシャ
ドウ
任意の部分に白地を残し，キャス
トシャドウを軽くみせる
*The shadow in black
marker.
The significance of the
shadow is weakened by
leaving the white blank
areas in optional places.*

The Point of Technique

②バックを描く。
(2) Sketch the back.

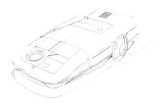

●液体マーカーによるバックグラウンドの描き方。
(1)必要部分をマスキングし，インスタントレタリングをはりこむ。

Sketching the background with a liquid marker
(1) Mask where necessary and attach instant lettering.

①アンダーレイ（下描き）の上にレイアウトペーパーを重ね，黒ボールペン，黒水性サインペン（日光ファインポイント0.2線幅）で線描きする。
バックグラウンドの範囲も線描きしておく。

(1) Place the layout paper over underlay (rough sketch), and draw the line with a black ball-point pen, black watersoluble sign pen (Nikko fine point 0.2 line width). Also draw the lines of the background range.

(2)絵具皿（陶磁製）に液体マーカーを入れ，溶剤（フローマスタークレンザー）で任意にうすめる。

(2) Pour liquid marker in a ceramic palette and dilute to desired consistency with solvent (flo master cleanser).

(3)コットンパッド又はティッシュペーパーを重ね折りにして金属クリップで挟み，これに皿の液体マーカーをしみこませて大胆なストロークで描いていく。

(3) Fold a cotton pad or tissue, fasten with a metal clip, dip it in the liquid marker on the palette, and use it to draw in large strokes.

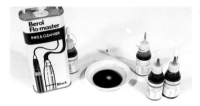

(4)セロハンテープでインスタントレタリングをはがす。
インクによる文字の滲みが残るが，かえってバックグラウンドの雰囲気に調和する。

(4) Remove the instant lettering with a piece of scotch tape. Although traces of ink in the form of the characters will remain, they will improve the harmony with the background.

⑥カーブのハイライトライン，明るいリフレクション等はスイープを使い，鉛筆型消しゴムで入れていく。
スプレーフィキサチーフをかけてパステルワーク終了。

(6) Apply sweeping strokes for the highlight line for the curve, bright reflection, etc., with a pencil eraser. Apply spray fixative to finish the pastel work.

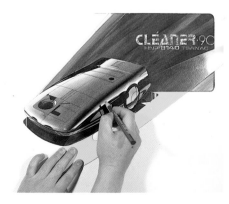

Drawing an Advanced Cleaner

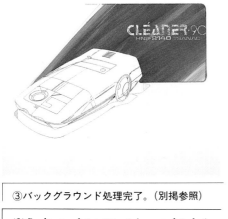

③バックグラウンド処理完了。（別掲参照）

(3) Background treatment is completed. (see The point of Technique)

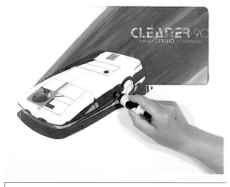

④リフレクション，キャストシャドウ等，細部の輪郭線は細描き用マーカー，本体の面のツブシはスピードライマーカーで描く。（クールグレイ No.5～No.10迄使用）

(4) Use a fine line marker for such outlines as the reflection and cast shadow and a marker for filling in the surface of the cleanser (use cool-grey No. 5 – No. 10).

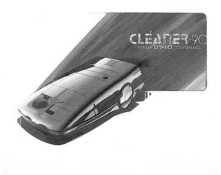

⑤マーカー処理が済んでからパステルワークに入る。粉状態にした黒，青のパステルをそれぞれ半々程度の量で混ぜ合わせ，重ね折りしたネルで塗っていく。
注）黒のパステルを単独で使うと仕上がりが汚いので，黒に他の任意の色を混ぜて使った方が綺麗に表現できる。

(5) After completing marker treatment, begin pastel work. Mix black and blue pastel in powder form in equal amounts, and use a folded soft cloth to apply the mixture. Note: Using the black pastel mixed with another desired color results in a better looking finish.

⑦車の部分は楕円定規，クリーナー本体はカーブ定規を使用し，白カラーペンシルでハイライトライン，デザインラインを入れていく。

(7) Use an oval ruler for the wheel and a curve ruler for the cleaner body, and draw the highlight line and design line with a white color pencil.

⑧白カラーペンシルによるタッチアップ終了。

(8) Finish touch-up with a white color pencil.

⑨最後に強いハイライト部分，デザインライン，グラフィックを白のポスターカラーで描き込んでいき完成する。

(9) Draw the strong highlights, design line, and graphics with a white poster color to finish the sketch.

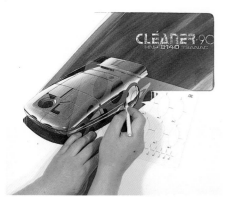

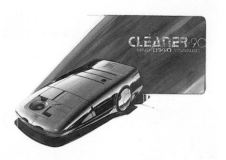

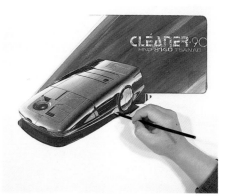

CLEANER·90
HNP-B140 TSANAC

液体マーカーによるラフなバック
処理
*Rough background
treatment with liquid
marker.*

インスタントレタリングによるマ
スキング
*Masking with instant
lettering.*

イライトライン，デザインライ
はカーブ定規を使い，白のカラ
ペンシルで入れる
*se a curve ruler and
hite color pencil for
e highlight line and
sign line.*

インドローイングは黒の水性サ
ンペンや黒ボールペンで
*e a black water-
ouble sign pen or
ack ball-point pen for
e drawing.*

のマーカーによるキャストシャドウ
*st shadow with a
ack marker.*

後にハイライトライン，デザイ
ライン，文字等を白のポスター
ラーで入れて完成
*aw highligh line,
sign line, characters,
., with a white
ster color to finish.*

CLEANER·90
HNP-B140 TSANAC

細描き用マーカーでシャープなリ
フレクションをボディラインに調
和するように入れる
*Use a fine marker to
draw a sharp reflection
in harmony with the
body line.*

鉛筆型消しゴムによるリフレクシ
ョン
*Draw reflection with a
pencil eraser.*

ボディの流れ（前後）にあわせる
ようにパステルをぬる
*Apply pastel in accord-
ance to the flow of the
body (from front to
back).*

①サインペン，色鉛筆，ボールペン等で描かれた多くの線描きクイックサムネイルスケッチ，コンセプトスケッチ等のデザインバリエーションから最終プレゼンテーションスケッチにするデザインを選択する。
ここでは，赤⇩印デザインを選んだ。

(1) A design is selected for final presentation sketch from a variation of sketches such as quick sketch drawn with sign pens, color pencils, ball-point pens, etc., and concept sketches. Hers, the one indicated by the red arrow was chosen.

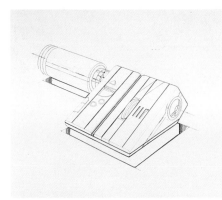

⑤完成したラインドローイング。

(5) Completed line drawing.

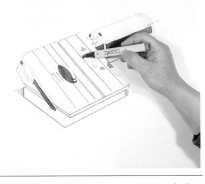

⑥裏面から，カラーマーカーでスイッチ部分を着色する。

(6) From the back side, apply color to the switch with a color marker.

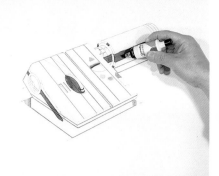

⑦裏面から，シリンダー部分（クロームメッキ），本体横のリフレクション（うつりこみ）をダークグレイ（No.7），黒マーカーで描き入れる。

(7) From the back side, draw the cylinder (chrome-plating) and the reflection beside the equipment with dark grey (No. 7) and black marker, respectively.

②選んだデザインをもとにして，トレーシングペーパーやレイアウトペーパー等に黒カラーペンシル，水性サインペン等で下描きをする。
機器の美しく見えるアングルを設定し，フリーハンドのパース（感覚的に描くパース）でラインドローイングしていく。
下描きは黒のカラーペンシル，水性サインペン，ボールペンが使いやすい。

(2) Based on the selected design, rough sketch is begun on tracing paper or layout paper with black color pencil, water-soluble sign pen, etc. Select a view from which the equipment appears the best, and begin line drawing based on free-hand perspective (estimated perspective). Water-soluble sign pen and ball-point pen are most convenient for rough sketch.

③下描き完成。
下描きのデザインライン（外形線）は強くはっきり表現する。

(3) Rough sketch is completed. The design line (outline) of the rough sketch must be strongly and clearly expressed.

④下描きの上に，ヴェラム紙を重ね，H程度の鉛筆で軽くトレスダウンし，下描きスケッチをはずす。
鉛筆の線描きスケッチの上から，0.3線幅の黒水性サインペンや黒ボールペンでラインドローイングする。
シリンダー部分や円いスイッチの所は楕円定規を使って描く。

(4) Place a vellum paper over the rough sketch, and use an "H" or comparable grade pencil to lightly trace down, and remove the rough sketch. Draw lines with a black water-soluble sign pen or black ball-point pen of 0.3 line width over the pencil line drawing sketch. Use an oval ruler for drawing the cylinder and round switches.

⑧表面から，キャストシャドウ（影），本体の黒部分，リフレクション等に黒のマーカーをつかって画面全体を引き締めていく。

(8) From the front side, draw the cast shadow, black part of the equipment, reflection, etc., with a black marker to tighten up both sides.

⑨マーカー処理完了後，パステルワークに入る。裏面，トレーシングペーパーとマスキングテープでマスキングし，パステルがはみ出さないようにする。

(9) After the marker treatment, begin pastel work. Mask the back side with tracing paper and masking tape to ensure pastel does not run.

⑩トレーシングペーパー上に，青系のパステルの粉を作る。

(10) Prepare blue pastel powder on the tracing paper.

⑪パステルを塗り易くするために，パステルの粉にベビーパウダーを20％程度混入する。

(11) To make the pastel easier to apply, add a a volume of baby powder equivalent to 20% of the volume of pastel powder.

⑫白ネル又はティッシュペーパーを重ね折りにし，粉状のパステルをつけて裏面よりヴァリューとグラデーションを表現していく。

(12) Fold a white soft cloth or tissue, apply powder pastel, and express value and gradation on the back side.

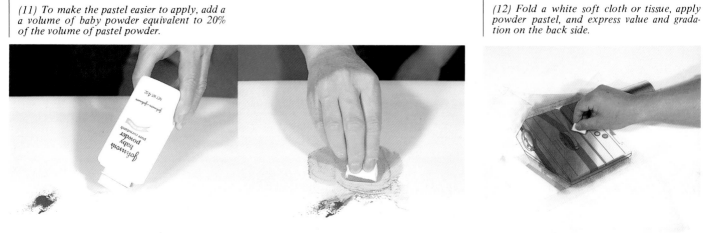

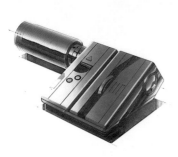

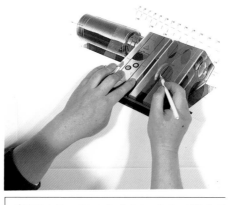

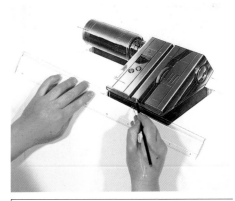

⑯パステルワーク終了。
スプレーフィキサチーフでパステルを定着させる。

(16) Pastel work is completed. Use spray fixative for permanently affixing the pastel.

⑰白のカラーペンシル（ベロールイーグルカラー）でハイライトライン，デザインライン，ディテールを描きおこしていく。

(17) Use a white color pencil for drawing highlight line, design line, and details.

⑱白のポスターカラーで文字，グラフィック細部を描き，直線のハイライトラインは溝引き定規を使ってタッチアップして完成する。

(18) Use a white poster color for drawing characters and details of graphics. Use a slotted ruler for drawing straight highlight line for touch up to finish.

⑬表面もマスキングして，パステルの粉がはみ出さないようにする。

(13) Mask the front side to prevent pastel powders from running.

⑭表面からもパステルでヴァリューとグラデーションを表現する。
すでに裏面からパステル処理がなされているので，表面からは軽くパステルを入れる。
裏面と表面からのパステル処理を行うことにより，滑らかな本体の面表現が出来る。

(14) Express value and gradation on the front side with pastel. As pastel treatment is completed on the back side, only light pastel treatment is needed on the front side. By providing pastel treatment on front and back sides, the planes of the equipment are expressed in smoother lines.

⑮面全体のパステルの拭き取りは煉りゴム，消しゴムを使用し，細かい部分を消したり，シャープなハイライトをつけるには鉛筆型消しゴム（ピンクパール）が効果的である。

(15) Use kneaded rubber or eraser for wiping off pastel from the entire surface. For erasing details or providing sharp highlights, a pencil eraser (pink pearl) is effective.

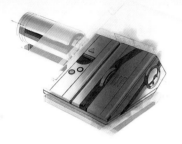

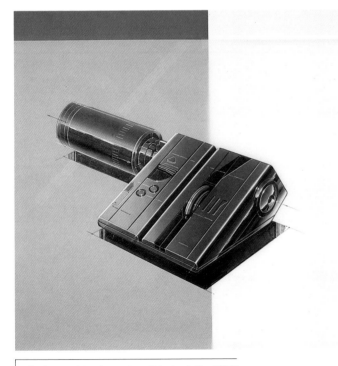

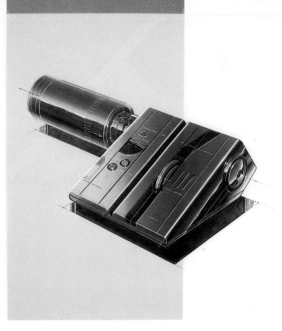

⑲ヴェラム紙によるスケッチはバックボード（裏紙）の色を変えると感じが違って見える。

(19) Change the color of backboard (back paper) when sketching on vellum paper for a different image.

(20) Completed sketch of BMC equipment (enlarged).

空の映りこみを青系パステルで両面から描く
Draw the reflection of the sky with blue pastel on both sides.

黒のマーカーで強いリフレクション（地平線の映りこみ）を入れ，クローム光沢の材質感を表現する
Draw a strong reflection of the horizon with a black marker, and express the chrome luster of the material.

ラインドローイングは黒ボールペン，水性サインペンで描く
Draw the lines with a black ball-point pen and water-soluble sign pen.

白のカラーペンシルによるハイライトライン，デザインライン
Highlight line and design line with a white color pencil.

地面の映りこみ
Reflection of the ground.

カラースイッチ部分は両面（表，裏面）からカラーマーカーで着色し，色の深みをだす
Apply color to the color switch from both sides (front and back) of the paper with a color marker to express the depth of the color.

青系パステルで両面描き
Blue pastel applied to both sides.

キャストシャドウを軽くみせるために，この部分をラフタッチで描く
Draw this area in rough touch to lighten the cast shadow.

この部分を明るく表現し，画面にめりはりをつける
Make this area bright to produce modulation on the sketch.

黒のマーカーによるキャストシャドウ
Cast shadow with a black marker.

白のポスターカラーでハイライトラインを入れる（溝引きによる）
Draw a highlight line with a white poster color (use slotted ruler).

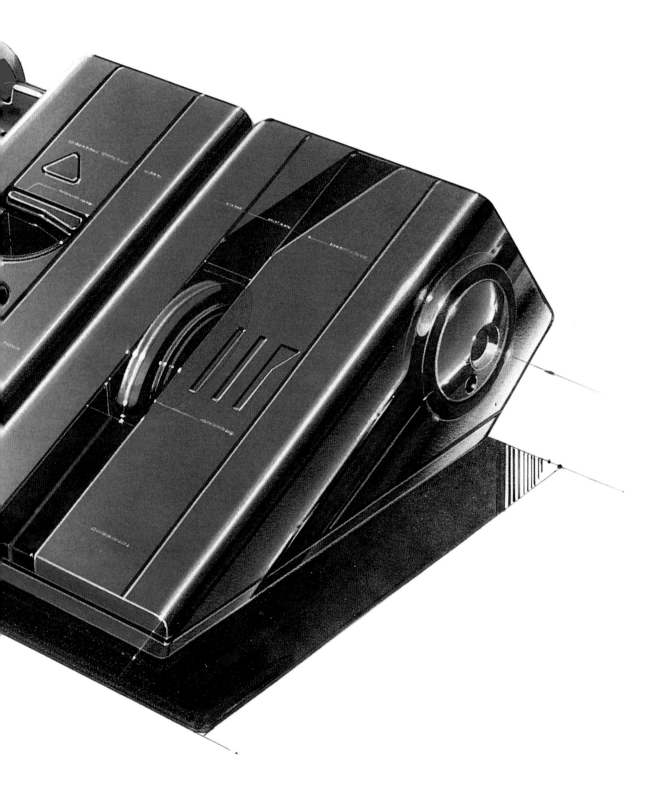

スキーブーツを描く Drawing Ski Boots

B 3 サイズヴェラム紙 *B3-size vellum paper*

①アンダーレイの上にヴェラム紙を重ね，黒ボールペンで線描きをする。
ブーツの曲線部分はレンダリングカーブ定規やスイープ，丸い部分は楕円定規を使って描く。

(1) Place a vellum paper over underlay and draw lines with a black ball-point pen. Use a rendering curve ruler for the curves of the boot and an oval ruler for the sweeping and round lines.

③バック処理完成。(このスケッチではバックとブーツの影を一緒に処理した)

(3) Completion of background treatment (in this sketch, the background and shadow of the boot were treated at the same time).

④マーカーで描き始める。
ブーツの黄色い部分は，直接マーカーを塗らないで，ティッシュペーパーを固くまるめ，先端にマーカーをしみこませてボカシ塗りをする。

(4) Begin drawing with a marker. The yellow part of the boot should not be colored directly with a marker. Dip the tip of a tightly compacted tissue in marker, and shade in the area.

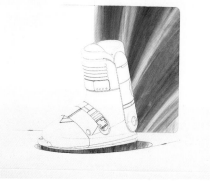

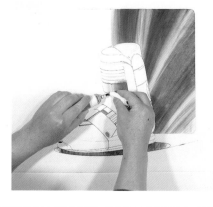

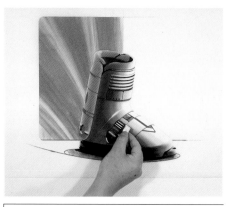

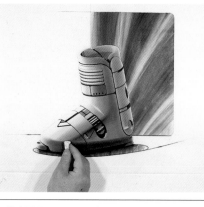

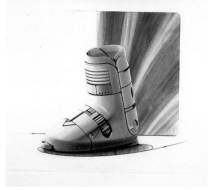

⑧裏面よりパステル処理をする。
パステルの裏描きで，ブーツの滑らかなハーフトーンの表現が容易にできる。

(8) Pastel treatment on the back side. Sketching the back side with pastel is an easy way to produce the smooth half-tone expression of the boot.

⑨表面よりパステル処理。
既にマーカー，パステルで裏描きされているので，表面からは軽くパステルをいれていく。
パステルのはみ出し，ハイライト部等を消しゴムで消し，フィキサチーフでパステルを定着させる。

(9) Pastel treatment on the front side. As back side is already treated with marker and pastel, only light pastel treatment from the front side is necessary. Erase pastel overrun, highlight areas, etc., with an eraser and use a fixative to permanently affix pastel.

⑩パステル処理完了。

(10) Completion of pastel treatment.

The Point of Technique

②バックを描く。
(2) Sketch the background.

●マーカーの溶剤(フローマスタークレンザー)とパステルによるバックグラウンドの描き方。
(1)バックの範囲をマスキングする。
(2)粉状にしたパステルにフローマスタークレンザーを加える。
(3)重ね折りしたティッシュペーパーを金属クリップで挟み，これに溶かしたパステルをふくませてラフなストロークで描く。
(4)マスキングをとって完成する。
注) 樹脂製の皿は溶剤に侵されることがあるので，陶磁製の皿を使ったほうがよい。

The Point of Technique

②バックを描く。 *(2) Sketch the background.*

●マーカーによるバックグラウンドの描き方。
(1)バックの範囲をマスキングする。
(2)マーカーを使いラフなストロークで描く。
(3)マスキングをとって完成する。
P.S.バックの描き方に定義はないが，早く仕上がって，リズミカルな雰囲気をだすにはラフなストロークで描いていくのがよいと思う。

Sketching the background with marker
(1) Mask the background area.
(2) Draw the background with a marker in rough strokes.
(3) Remove the masking to finish.
Note: Although there is no best way for drawing the background, drawing in rough strokes will complete the work faster and produce a sense of rhythm in the sketch.

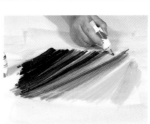

⑤マーカー処理が続く。

(5) Continue marker treatment.

⑥黒マーカーの裏描きで微妙なハーフトーンの表現効果がでてくる。

(6) Sketch on the back side with a black marker to create a subtle half-tone expression effect.

⑦キャストシャドウ，細部等を黒マーカーで描き画面全体を引き締める。

(7) Draw the cast shadow and details with a black marker to tighten up the entire sketch.

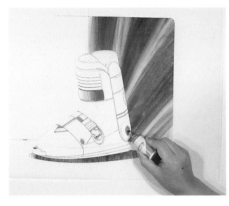
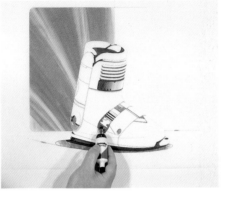
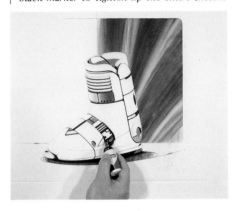

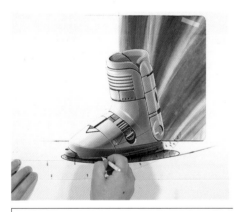
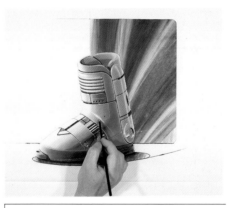

⑪白のカラーペンシルでハイライトライン，デザインラインを描き進める。
デザインラインをすっきりさせるためにカーブの部分にはレンダリングカーブ定規，スイープを使って表現する。

(11) With a white color pencil, continue to draw the highlight line and design line. To draw clean design line, use a rendering curve ruler and sweep for the curves.

⑫白のポスターカラーで，強いハイライト部分，デザインラインとグラフィックを入れる。

(12) With a white poster color, draw the strong highlights, design line, and graphics.

Sketching the background with marker solvent (flo master cleanser) and pastel.
(1) Mask the background area.
(2) Add flo master cleanser to pastel in powder form.
(3) Hold a folded tissue with a metal clip, and dip it in the dissolved pastel, and draw in rough strokes.
(4) Remove the masking to finish.
Note: Use a ceramic palette as plastic palette may be corroded by solvent.

黒マーカーの裏描き
Drawn from the back with a black marker.

ラインドローイングはカーブ定規, 楕円定規等を使いボールペンで描く
Draw lines with a ball-point pen using curve ruler, oval ruler, etc.

色マーカーでボカシぬり
Create a shade with a color marker.

パステルの両面（表面, 裏面）描きで, ブーツの材質感（微妙なハーフトーン）を表現する
Express the material slight half-tone) of the boot on both sides (front and back) with pastel.

パステルのぬり残しによるハイライト
Highlight created by not applying pastel.

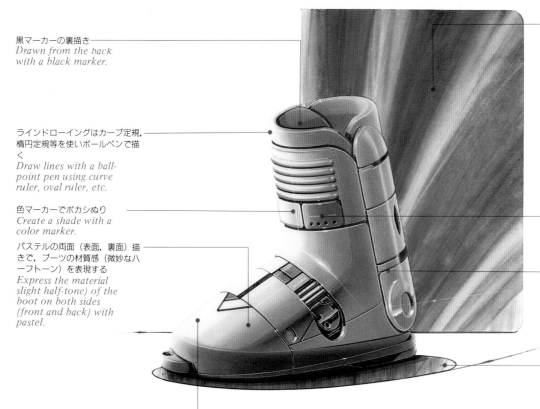

粉にしたパステルにフローマスタークレンザー（マーカー溶剤）を加え, これを重ね折りしたティッシュペーパーにふくませてラフなストロークでバックを描く
Dip a folded tissue to a solution made by adding flo master cleanser (marker solvent) to powder pastel, and use it to draw the background in rough strokes.

白のポスターカラーで文字を入れる　注）文字のインディケーションは簡潔に
Write the characters with white poster color. NB: Character indication must be concise.

白のカラーペンシルでハイライトラインを入れる
Use a white color pencil to draw highlight lines.

キャストシャドウはバック処理と同じイメージに
The cast shadow should be of the same image as the background treatment.

⑬完成したスキーブーツのスケッチ。

(13) Completed sketch of ski boot.

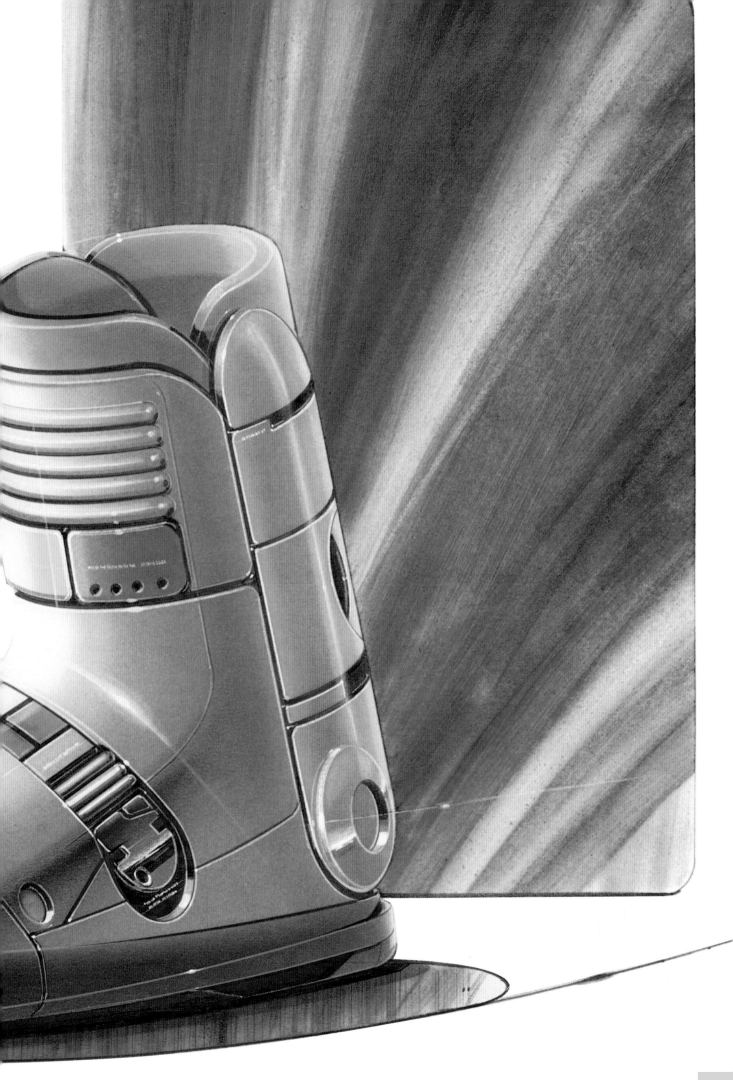

B 3 サイズジアゾコピー紙（青写真用の感光紙）*B3-size diazotized copy paper (Blueprint paper)*

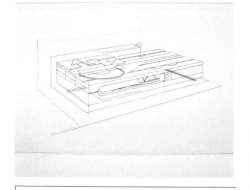

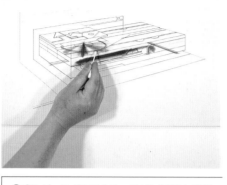

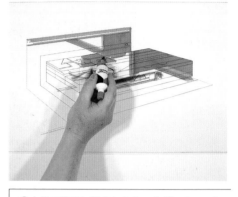

①トレーシングペーパーに，黒の水性サインペン，ロットリングなどで基本的なラインドローイングし，複写機（青写真用）にかけコピーする。

(1) Draw in the basic lines on tracing paper with the use of black water-color felt-tip pen and draft pen, and then copy it on a mimeograph.

②CD ディスク面のカラースピン表現は，直接マーカーを塗らないで，綿棒の先端に色マーカーをしみこませてボカシ塗りをする。

(2) The color of the spinning disk should be shaded in with the tip of a cotton-bud moistened with the color marker instead of being applied directly.

③本体の明るい部分からクールグレイマーカーで描いていく。
ここでは，クールグレイのNo.5からスタートした。

(3) Paint in from the light section of the player in cool-grey marker.
Cool-grey No. 5 has been used here.

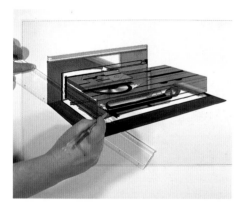

⑦既にマーカーによって本体各面の明暗，リフレクション等が表現されているが，よりコントラストのきいた，いわゆるインパクトの強いスケッチにするために，陰影，リフレクション，バック，キャストシャドウの部分に黒のポスターカラーを使っていく。

(7) In order to increase the impact of the sketch, the recently shaded areas in the reflection, the shadows and the back of the CD player have had black poster color applied even though these portions have already been expressed with markers.

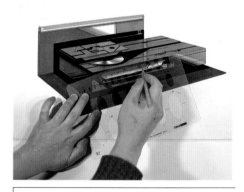

⑨シルバー，白のカラーペンシルでハイライトライン，デザインライン，ディテールなどを描いていく。
備考）シルバーカラーペンシルはノリがよく，又，描きあがった状態ではライトグレイに見えるので，弱いデザインライン，ディテール等の表現には適しているといえる。

(9) Draw in the highlight lines, the design lines and the details with silver and white color pencils.
(NB) A silver colored pencil may be suitable for expressing gentle design lines and details as it spreads well and looks like light grey when it is finished.

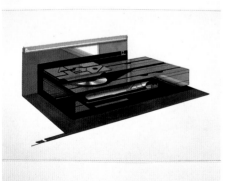

⑧黒ポスターカラーの使用により，一段と引き締まったスケッチ。
黒ポスターカラー処理終了。

(8) The much braced-up sketch after the use of black poster color.
The black poster color process has now been completed.

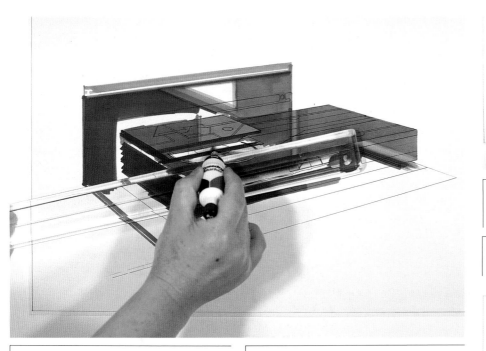

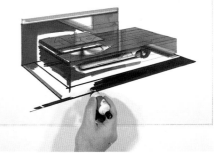

④クールグレイマーカーのNo. 6 ～No. 8 を使い、全体のバランスをはかりながら、ヴァリュー、リフレクション、バック等を描いていく。

⑤クールグレイマーカーNo. 9 ～No.10で陰影部分、キャストシャドウ、バック部分等を描き、画面全体を引きしめる。

(4) With the use of cool-grey markers between No. 6 and No. 8, draw in the volume, the reflection and the back while calculating the overall balance.

(5) Shade in the shadow and the back section with cool-grey No. 9 and No. 10 to brace up the picture.

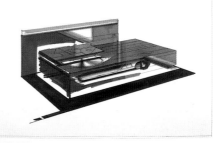

⑥クールグレイマーカー処理が終わったスケッチ。

(6) The sketch with the cool-grey marker process complete.

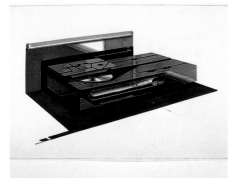

⑩シルバー、白のカラーペンシルで、ハイライトライン、デザインライン、ディテールが表現されたスケッチ。
カラーペンシルワーク終了。

(10) The sketch with the highlight lines, design lines and details expressed with the silver and white colored pecils.
The colored pencil work is now completed.

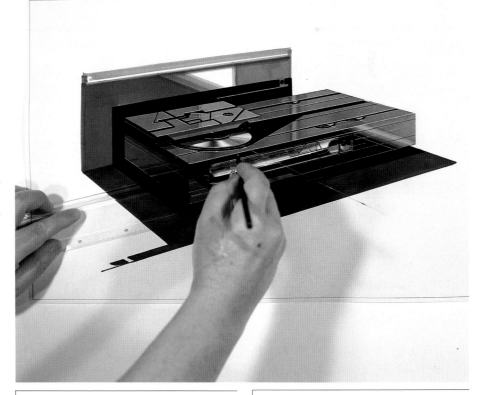

⑪白のポスターカラーでハイライトライン、デザインライン、ディテールを描き完成する。プレーヤーの精緻感を表現するために、直線部分は溝引きを使い、できるだけ線の太さにムラがないように描く。

(11) With the use of white poster color completed the highlight lines, design lines and details of the player. In order to express the minuteness of the player it is advisable to use a grooved-ruler to draw in the straight lines and to keep all lines to the same thickness.

⑫完成した CD プレーヤーのスケッチ。

(12) The completed sketch of the CD Player.

バックグランドはクールグレイNo.6
〜No.8を使って描く

*Paint the background
roughly with the use of
cool-grey markers between
No. 6 to No. 8.*

綿棒の先端に色マーカーを滲みこ
ませてボカシぬりする

*Apply colored marker to
the tip of the cotton bud
and paint in the disc.*

バックグランドの映り込みをクー
ルグレイNo.7位を使っていれる

*Draw in the shiny area of
the background with the
use of cool-grey No. 7.*

白のポスターカラーでハイライト
ライン，デザインラインを描く
プレーヤーの精緻感を表現するた
めに，溝引きを使ってハイライト
ラインなどを描きいれる

*Draw in the highlight and
design lines with white
poster color.
Draw the highlight lines
with the use of a grooved-
ruler to express the
minuteness of the player.*

基本的パースがコピーされたジア
ゾ紙に，黒水性サインペンを使っ
てラインドローイングをする

*Draw lines of the diazo-
tized paper onto which the
basic drawing has already
been copied.*

シルバーのカラーペンシルでデザ
インラインを薄くいれる

*Draw in the gentle design
lines with the silver colored
pencil.*

黒のマーカーによるキャストシャ
ドウ

*Add black marker to the
shadow.*

白のポスターカラーで文字などの
インディケーションを簡潔，抽象
的に表現する

*The letter indication
should be expressed
compactly (with style)
and abstractly with
white poster color.*

クールグレイNo.5〜No.7で重ねぬ
りをしてリフレクションをつける

*Draw in the reflections
repeatedly with the use of
color schemes between
cool-grey No. 5 to No. 7.*

黒のマーカーで描いたキャストシ
ャドウ部分に，黒ポスターカラー
を重ねぬりして画面を引き締める

*Black poster color has been
added to the shadowed
areas previously drawn in
black marker in order to
brace up the picture.*

黒ポスターカラーでリフレクショ
ンを入れ，コントラスト（めりは
り）を強調する

*Draw the reflections in
black poster color to
emphasize the contrast.*

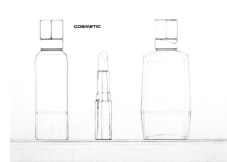

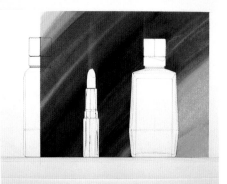

①下描きの上にヴェラム紙を重ね，黒ボールペン（細），黒水性サインペン（0.2㎜程度）で，外形，ガラスの肉厚，リップスティック金属部分のリフレクション等を線描きする。

(1) First apply a sheet of vellum paper on top of the sketch, and using a black ball-point pen (thin nib) and a black water-colored felt-tip pen (0.2mm) draw the outlines, the thickness of the glass bottle and the reflection on the metal part of the lipstick.

②必要部分をマスキングし，液体マーカーでバックグラウンドを描く。
ここでは，重ね折りしたティッシュペーパーを金属クリップで挟み，これにブラウン系の液体マーカーをふくませ，ラフなストロークで描いてある。

(2) Masking tape should be applied where necessary and then the background should be painted in with liquid markers.
The background here has been painted with rough strokes by using a piece of folded tissue paper held firm in a metal clip and daubed with brown liquid marker color.

③ヴェラム紙の裏面よりローズ系，黒，ダークグレイ等のマーカーで，ビンの肉厚とメタルキャップ，リップスティックとその金属部分などを描いていく。
微妙なハーフトーンの表現には，紙の表，裏の両面から描いていくのがよい。

(3) Draw the thickness and the metal cap of the bottle, the lipstick and its metal parts with rosy shades and black and grey color markers from the background surface of the vellum paper.
The most effective way to express the very slight difference in the half-tone coloring is to bring the paint strokes in from both sides of the paper.

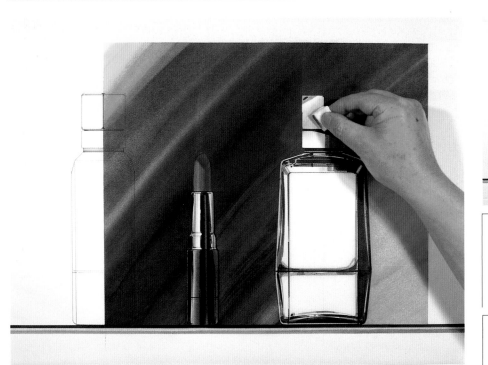

⑦ビン（化粧水）はオリーブグリーンのパステルを使って描く。
広い面は練りゴム，細かい部分は鉛筆型消しゴムを使ってパステルを拭きとる。
スプレーフィキサチーフでパステルを定着してパステル処理終了。

(7) Draw the bottle containing skin-lotion in olive green pastel. Rub the pastel in the large section with a soft-rubber eraser and the smaller section with a pencil eraser. Apply the spray fixative to fix the pastels and complete the pastel process.

⑥リップスティックの金属部分，ビンのキャップは，重ね折りしたネル又はティッシュペーパーに粉状のクロームイエローのパステルをつけて描き，ゴールドの質感をだす。

(6) Using a folded flannel or tissue paper, apply the powdered chrome-yellow pastel. Paint the metal part of the lipstick and the bottle cap to produce the gold texture.

Drawing Cosmetics

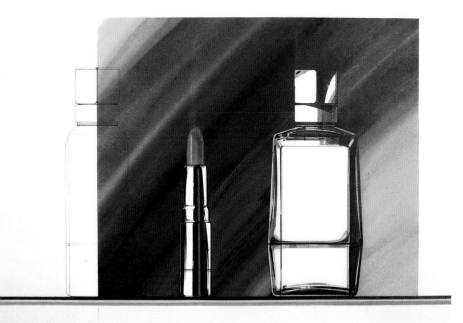

④紙の表面からダークグレイ，黒マーカーを使って，リップスティック，ビンのリフレクション部分などを描く。
リップスティック，ビン下部の接地する水平線は，黒，ピンク，グリーンのマーカーで描き，画面に変化をつける。

(4) Using grey and black markers draw the lipstick and the reflective parts of the bottle from the foreground of the paper.
The vertical line that joins the lower part of the lipstick and the bottle should be drawn in black, pink and green markers to produce a little variety to the picture.

⑤紙の両面からのマーカー処理完了。

(5) All processing from both sides of the paper with the markers has now been completed.

⑧白のカラーペンシルでハイライトライン，デザインライン，ディテールを描いていく。

(8) Draw in the highlight lines, the design lines and the details with a white pencil.

⑨白のカラーペンシルによって，ハイライトライン，デザインライン等がはいったスケッチ。

(9) The sketch with highlights and design lines added in white pencil.

⑩文字をいれる。
ここでは，白のインスタントレタリングを使った。

(10) Lettering.
White instant lettering was used here.

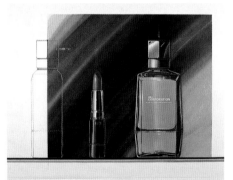

⑪白のポスターカラーでハイライト，デザインラインなどのタッチアップをして完成する。

(11) White poster color is added to draw the highlights and design lines for the final touch to the picture.

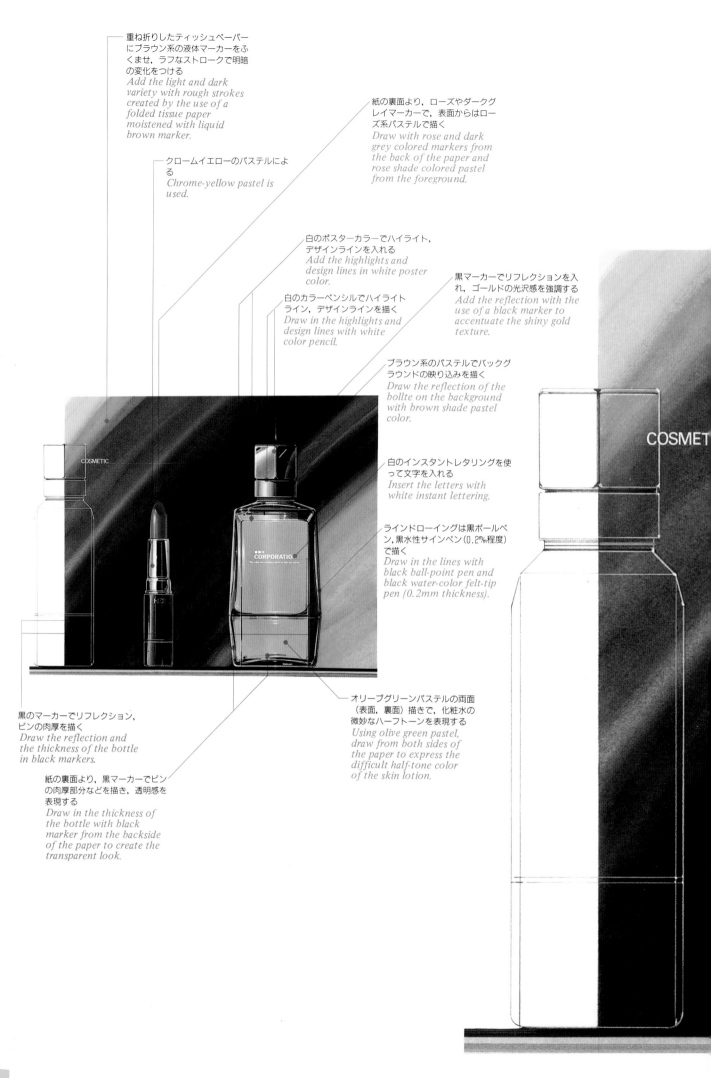

重ね折りしたティッシュペーパーにブラウン系の液体マーカーをふくませ, ラフなストロークで明暗の変化をつける
Add the light and dark variety with rough strokes created by the use of a folded tissue paper moistened with liquid brown marker.

クロームイエローのパステルによる
Chrome-yellow pastel is used.

紙の裏面より, ローズやダークグレイマーカーで, 表面からはローズ系パステルで描く
Draw with rose and dark grey colored markers from the back of the paper and rose shade colored pastel from the foreground.

白のポスターカラーでハイライト, デザインラインを入れる
Add the highlights and design lines in white poster color.

白のカラーペンシルでハイライトライン, デザインラインを描く
Draw in the highlights and design lines with white color pencil.

黒マーカーでリフレクションを入れ, ゴールドの光沢感を強調する
Add the reflection with the use of a black marker to accentuate the shiny gold texture.

ブラウン系のパステルでバックグラウンドの映り込みを描く
Draw the reflection of the bollte on the background with brown shade pastel color.

白のインスタントレタリングを使って文字を入れる
Insert the letters with white instant lettering.

ラインドローイングは黒ボールペン, 黒水性サインペン(0.2㎜程度)で描く
Draw in the lines with black ball-point pen and black water-color felt-tip pen (0.2mm thickness).

黒のマーカーでリフレクション, ビンの肉厚を描く
Draw the reflection and the thickness of the bottle in black markers.

紙の裏面より, 黒マーカーでビンの肉厚部分などを描き, 透明感を表現する
Draw in the thickness of the bottle with black marker from the backside of the paper to create the transparent look.

オリーブグリーンパステルの両面(表面, 裏面)描きで, 化粧水の微妙なハーフトーンを表現する
Using olive green pastel, draw from both sides of the paper to express the difficult half-tone color of the skin lotion.

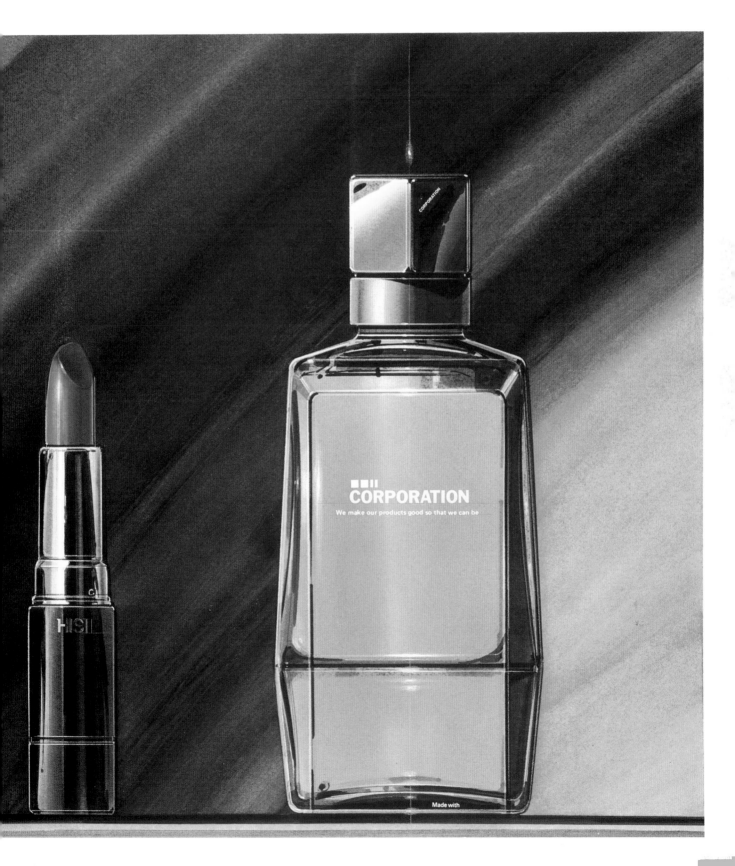

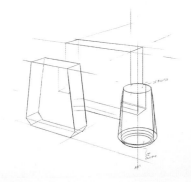

①黒のカラーペンシルで下描きをする。
注）手前のガラス器を通し、後ろにある直方体のガラス器のデザインライン（輪郭線）が屈折して見えるのに注意。
線描きの時点で、透明ガラス器の特徴をとらえ表現しておく。

(1) Draw in black color pencil.
NB: Take care to note that rectangular shapes placed behind the glass in a design will appear curved when viewed through the glass. The distinguishing features of clear glass should be grasped and expressed in the drawing stage.

②下描きスケッチの裏面をHB程度の鉛筆で塗りつぶす。

(2) Paint out (smear out) the back of the sketch in H.B. or soft pencil.

③カラーペーパーの上に下描きスケッチを重ね、黒ボールペン又は硬質鉛筆でデザインライン、ディテール等をなぞり描きし、転写する。

(3) Place the sketch on top of the color paper and trace the design lines and details in black ball-point pen or hard pencil to copy.

⑥カラーペンシルでパターンをいれる。

(6) Paint the patterns in colored pencil.

⑤クールグレイマーカーNo.5位でガラス器の肉厚、パターン等を描いていく。

(5) Draw in the thickness and pattern of the glass in No. 5 cool-grey marker.

The Point of Technique

●ムードが大切なガラス器，宝石関係のデザインスケッチではバックグラウンドの表現は欠かせない。
パントンカラーペーパーのバックグラウンド付は，色，グラデーションがきれいにプリントされているので，ムードを要求するスケッチの作成には最適な用紙といえる。
なんといっても，バックグラウンドを描く手間が省ける。

Background moods become indispensibly important when it comes to drawing design sketches of glasswear or jewels.
Panton color paper might be the ideal paper to produce sketches that are in need of this mood as the colors and gradations have been printed beautifully.
Above all it will save one the trouble of painting in a background.

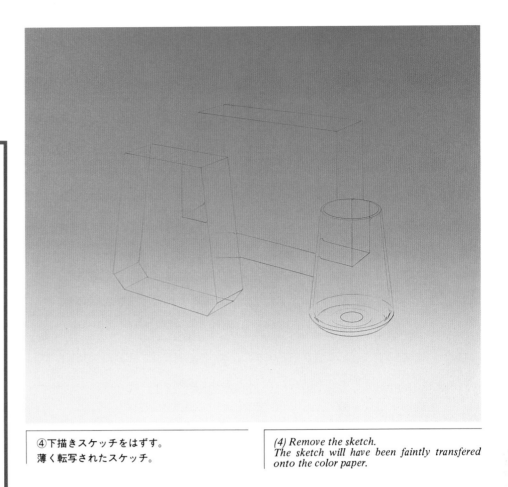

④下描きスケッチをはずす。
薄く転写されたスケッチ。

(4) Remove the sketch.
The sketch will have been faintly transfered onto the color paper.

⑦粉状にした白のパステルを，重ね折りしたネルにつけ，ハイライト部分，リフレクション部分を描く。

(7) Add the highlights and reflections with a double-folded flannel applied with white powder pastel.

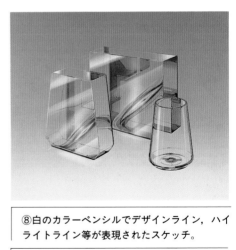

⑧白のカラーペンシルでデザインライン，ハイライトライン等が表現されたスケッチ。

(8) The sketch of which the design lines and highlight lines have been expressed in white colored pencil.

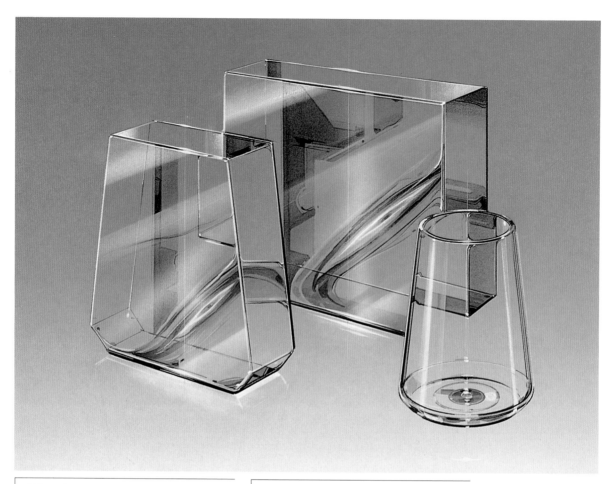

⑨白のポスターカラーでディテール，デザイン
ライン，ハイライトラインをいれて完成。

(9) Add the details, the design lines and the highlight lines in white poster color to complete.

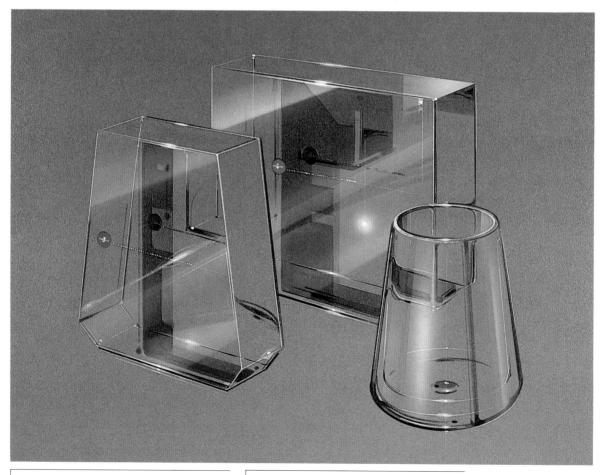

⑩グレイのカラーペーパー（グラデーション付）
に描かれたガラスの造形物のスケッチ。

(10) The glasswear sketch drawn on grey paper (with gradation).

クールグレイマーカーNo.8でぬる
Paint with cool-grey marker No. 8.

粉状にした白のパステルを，重ね折りしたネルにつけ，ハイライト部分，明るいリフレクション部分を描く
Apply white pastel onto a double-folded flannel to draw in the highlights and lighter reflection areas.

ハイライトライン，ハイライトスポットは白のポスターカラーでいれる
Insert the highlight lines and spots with white poster color.

スケッチ用紙はパントンカラーペーパーのバックグラウンド付(青)を使用
既にバックグラウンドが印刷されているので，バックを描く手間が省ける
Use color paper with a blue background for the sketch paper. This will save time and trouble later as the background will already be complete.

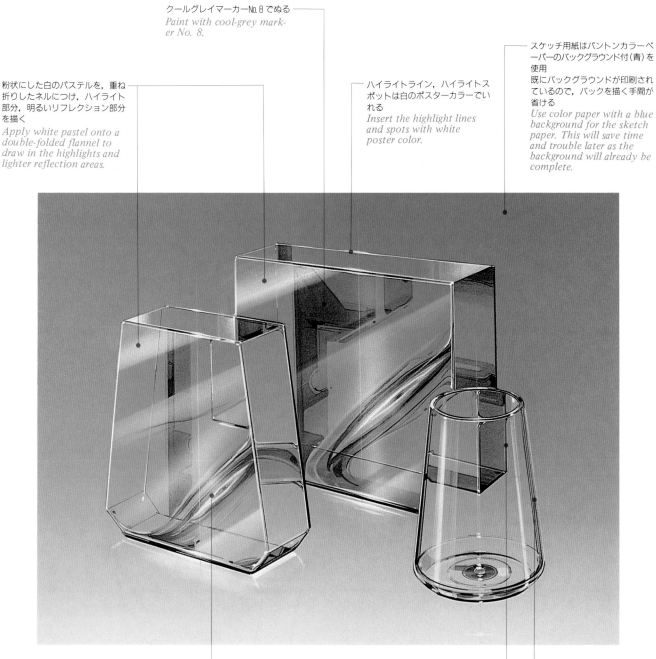

クールグレイマーカーNo.5と紫，黄のカラーペンシルで模様を描く
Draw in the color patterns in cool-grey marker No. 5, purple and yellow pencil.

手前のガラス器を通し，後ろの直方体のガラス器のデザインライン(輪郭線)が屈折して見えるのに注意
ラインドローイングの時点で，透明ガラス器の特徴をとらえて表現しておく
Note that the design lines (outline) of the cuboid shape is refracted through the glass container in the front. It is important to express the features of the clear glass containers in the line drawing stage.

白のカラーペンシルによるデザインライン
The white pencil design lines.

トラベリングバッグを描く

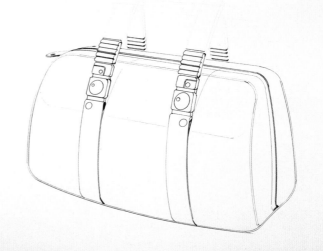

①下描きの上にレイアウトペーパーを重ね，黒水性サインペン（0.2〜0.3㎜程度）でラインドローイングする。

(1) Place the layout paper on top of the sketch and draw in the lines using a black water-color felt-tip pen (0.2 ~ 0.3mm).

②グリーン系（バッグの色）マーカーで暗いリフレクション部分等を描いていく。

(2) Work on the dark reflections with green shade (color of the bag) markers.

③クールグレイのマーカー（No. 6 〜No.10）でバンド部分を描く。

(3) Draw in the belt in cool-grey markers (No. 6 ~ No. 10)

76

Drawing a Travel Bag

④黒のマーカーでキャストシャドウ等をいれ，
マーカー処理が終わる。

(4) Add the shadows in black marker to complete the marker work.

⑤重ね折りしたネルに粉状にしたグリーン系パ
ステルをつけて塗っていく。

(5) Apply powdered green pastel to a double-folded tissue paper to paint.

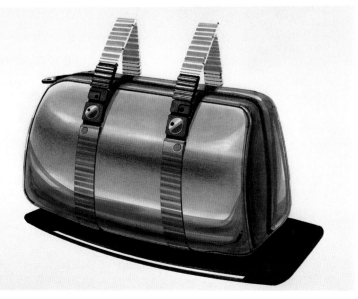

⑥ハイライト部分，明るいリフレクション部分，
パステルのはみだしは，練りゴム，消しゴムで
拭き取る。
スプレーフィキサチーフでパステルを定着して
パステル処理終了。

(6) Wipe out the light reflection areas and excess pastel with a soft rubber or a pencil eraser. Apply some fixative spray to set and complete the pastel work.

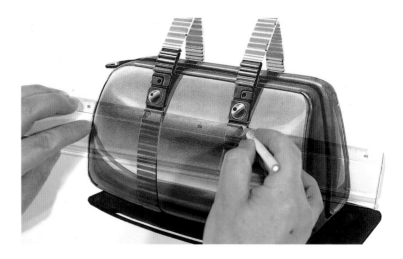

⑦白のカラーペンシルでディテール，ハイライ
トライン，デザインラインを描いていく。

*(7) Work on the details, highlight lines and
design lines in white pencil.*

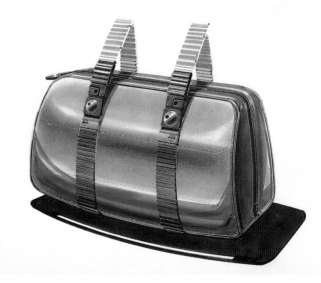

⑧白のカラーペンシル，黒のカラーペンシルで
ステッチ（糸の縫目）をいれる。
備考）ステッチを描くことにより，革らしい表
現となる。

*(8) Add the stitches in white and black pencil.
NB: The texture of the leather is expressed
by these stitches.*

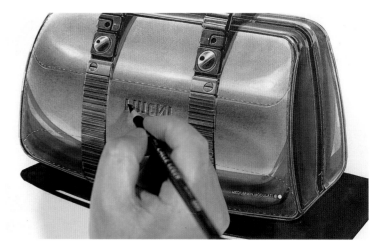

⑨黒のカラーペンシル，白のカラーペンシルで
凹文字（ブランド）をいれる。

*(9) Add the embossed letters (brand name) in
black and white pencil.*

⑩白のポスターカラーでハイライトライン，デ
ザインライン，ディテールを描く。

*(10) Draw in the highlight lines, the design
lines and the details in white poster color.*

⑪完成したトラベリングバッグ。
（バックグラウンドなし）

(11) The completed sketch of the travel bag.

⑫別紙にバックグラウンドを描き，これに完成
したスケッチ⑪を切り貼りする。

*(12) Draw the background on a separate piece
of paper and stick the cut-out (11) onto this.*

⑬スケッチ全体をながめ，描き足りない部分に
さらに手を加える。
ここでは，バンド部分の上部をラフタッチで描
き足した。

*(13) Examine the picture and add here and
there if necessary. A rough touch was added
to the upper part of the belt here.*

白のカラーペンシルと黒のカラー
ペンシルでステッチ（糸目）を描
いて革の質感を表現する
Draw in the stiches (thread)
in white and black to ex-
press the texture of the
leather.

クールグレイマーカーNo. 6～No.10
でバンド部分を描く
Use cool-grey markers No.
6 ~ No. 10 to draw in the
belt.

白のポスターカラーでハイライト
ラインをいれる
Insert the highlight lines
in white poster color.

粉状のグリーンのパステルを，重
ね折りしたネルにつけてぼかし塗
りをする
Apply powdered green
pastel to a double-folded
flannel and shade off.

別紙にバックグラウンドを描き，
完成したスケッチを切り貼りする
Draw the background on a
separate piece of paper and
then cut out the picture
and stick it on.

白のカラーペンシルでデザインラ
インをいれる
Draw in the design lines
in white pencil.

黒のマーカーでキャストシャドウ
を描く
任意の部分を塗り残し，キャスト
シャドウを軽くみせる
Draw in the shadow in
black marker leaving one
spot unpainted in order to
give off an impression of
lightness in the shadow.

グリーン（バッグ本体の色）のマ
ーカーで暗いリフレクション部分
を描く
Draw the dark reflection
in green (body color)
marker.

黒，白のカラーペンシルでブランド
ド（凹文字）をいれる
Insert the brand name in
black and white pencil
(embossed lettering).

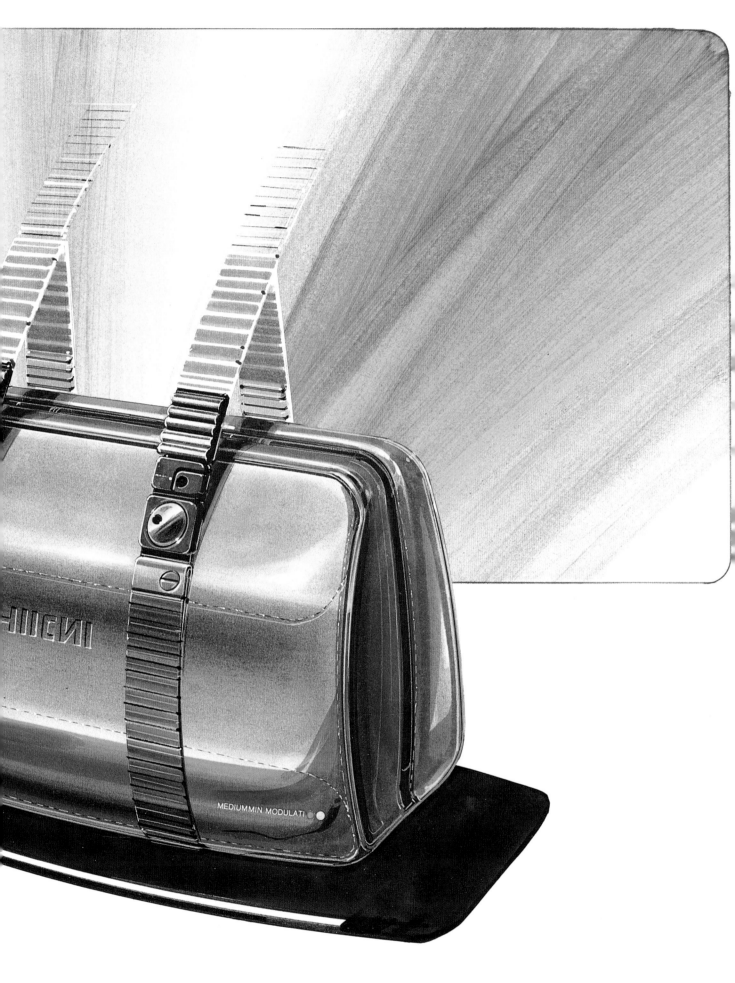

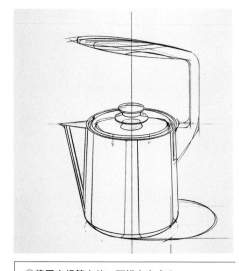

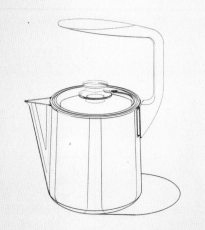

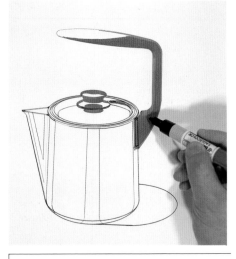

①楕円定規等を使い下描きをする。
下描きは太めの線で描いておいたほうが、スケッチ用紙を上に重ねた時にトレスし易い。

(1) Use an oval ruler to draw the sketch thicker lines are recommended to enable easy tracing.

②下描きの上にレイアウトペーパーを重ね、把手は赤、本体は黒のボールペンでラインドローイングする。

(2) Place the piece of layout paper on top of the sketch. Draw the handle in red ball-point pen and the body in black ball-point pen.

③把手部分は赤系マーカーを使い塗っていく。

(3) Use a red shade marker to paint in the handle.

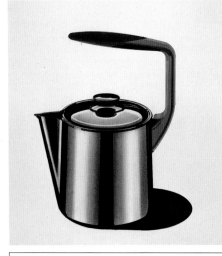

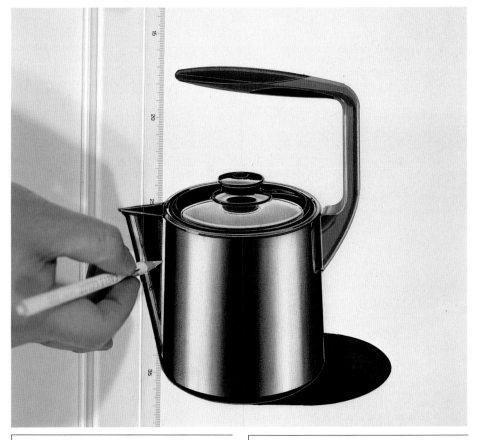

⑥パステルのはみだし、ハイライト面、明るいリフレクション部分などは練りゴム、鉛筆型消しゴムで拭きとる。
スプレーフィキサチーフでパステルを定着してパステル処理終了。

(6) Wipe out the excess pastel, the highlight lines and the light reflection areas with a soft rubber or pencil eraser.

⑦白のカラーペンシルでデザインライン、ハイライトライン、ディテールを描く。
直線部分は直定規を使い、曲線部分はカーブ定規、スイープを使って表現する。

(7) Draw in the highlight lines, the design lines and the details with white pencil.

Drawing a Kettle

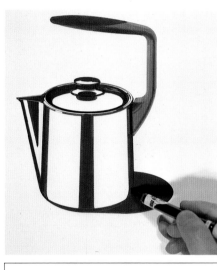

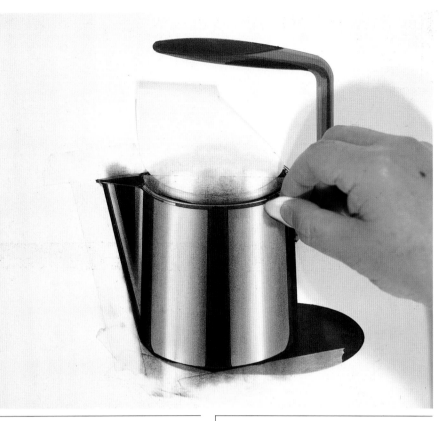

④黒のマーカーを使って，ふた，本体のリフレクション，キャストシャドウを描く。

(4) Use a black marker to draw in the lid, the reflection on the body and the shadow.

⑤必要部分をマスキングし，粉状にした黒パステル（黒60%，青40%の混ぜ合わせ）を，重ね折りしたネル又はティッシュペーパーにつけ，本体の面を縦方向のストロークで塗る。

(5) Apply masking to the areas necessary. Use black powder pastel (mixture of 60% black and 40% blue) on a double-folded tissue or flannel and paint in the body surface using verticle strokes.

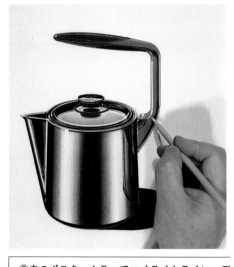

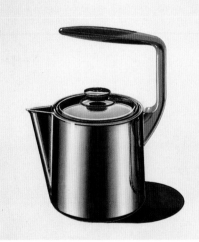

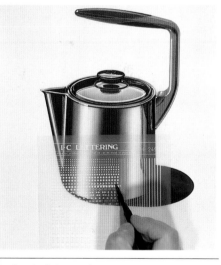

⑧白のポスターカラーでハイライトライン，デザインライン，ディテールを描く。
直線部分は溝引きを使ってシャープにいれる。
備考）光沢ステンレスの材質感をより強く表現するために，本体（把手の付近）に黒のカラーペンシルでリフレクションをいれた。

(8) Use white poster color to add the highlight lines, design lines and details. Use a grooved ruler to draw the straight lines neatly. NB: Reflection was added to the body (near the handle) in black pencil in order to strongly express the shiny texture of the stainless steel.

⑨白のポスターカラーでハイライトライン，デザインライン等がはいったスケッチ。

(9) The sketch in which the highlight lines and design lines have been painted in white poster color.

⑩文字（ブランド）をいれる。
ここでは，白のインスタントレタリングを使った。

(10) Put in the letters (brand name).

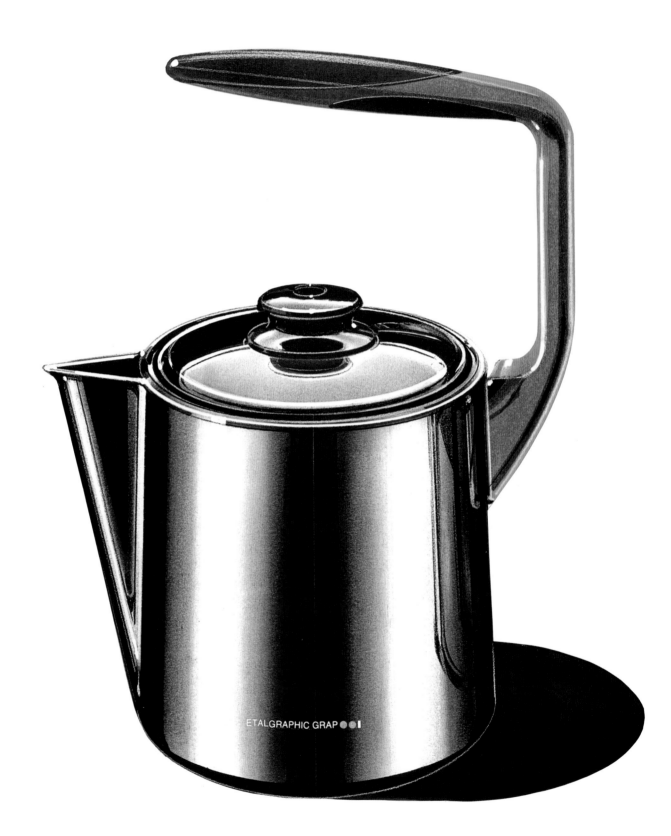

ETALGRAPHIC GRAP ●●▮

⑫めりはり（コントラスト）のあるスケッチに
するために，完成したスケッチ⑪を黒のイラス
トボードに切り貼りする。

(12) Stick the completed sketch (11) onto a black illustration board in order to give it contrast.

黒の細描きマーカーでリフレクシ
ョンを描く
Draw the reflection in thin black marker.

白のポスターカラーでハイライト
ラインをいれる
Add the highlight lines in white poster color.

赤のマーカーによる
Done with a red marker.

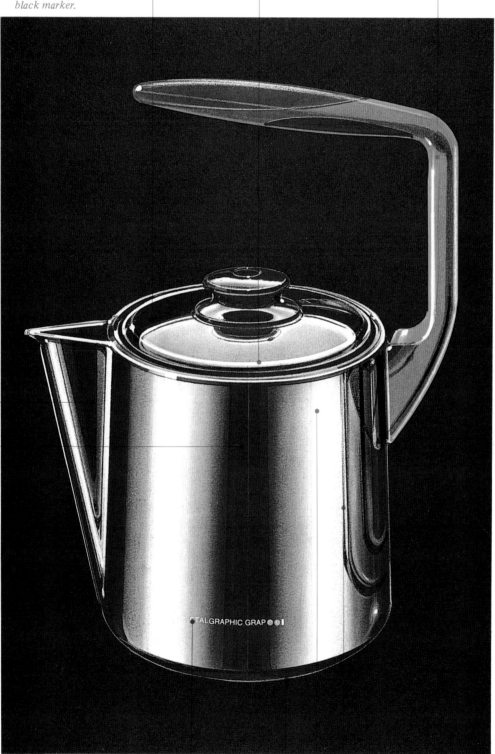

白のインスタントレタリングでブ
ランド名を貼る
Insert the brand name. Stick on white instant lettering.

白のカラーペンシルによるデザイ
ンライン
Design line with a white color pencil.

めりはり（コントラスト）のある
スケッチにするために，完成した
スケッチを黒のイラストボードに
切り貼りする
Stick the completed sketch onto a black illustration board in order to create a sketch with a clear contrast.

黒のカラーペンシルで，まわりか
らの映り込みをいれて，ステンレ
スの質感を表現する
Express the texture of the stainless steel by adding the reflection from the surrounding area in color pencil.

黒パステル（黒60％，青40％）の
ぼかし塗り
Shade off the black pastel (a blend of 60% black and 40% blue)

A 3 サイズレイアウトペーパー（PMパッド白）　　A3-size layout paper (white PM pad)

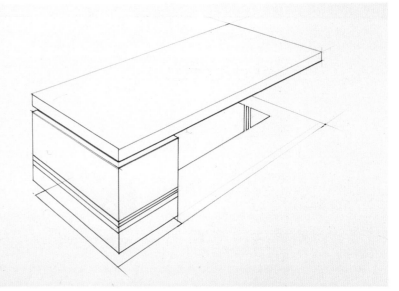

①レイアウトペーパーに黒水性サインペン（0.2
㎜程度）でラインドローイングする。

*(1) Draw the lines on the layout paper in
black felt-tip pen (0.2mm).*

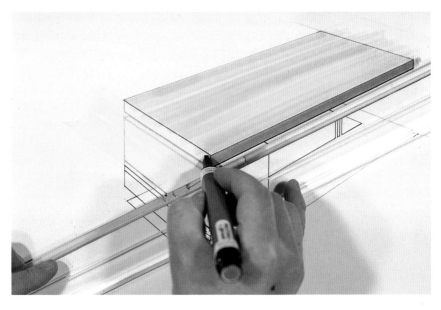

②木目部分をマスキングし，茶系のマーカー（こ
こではチークに近い色）で横方向のストローク
で描く。
木目部分の三面に明暗の調子をつける。

*(2) Apply masking to the wooden parts and
using side strokes paint in a shade of brown
(a color close to teak should be used here).
Add the light and dark tones to the three
sides of wood.*

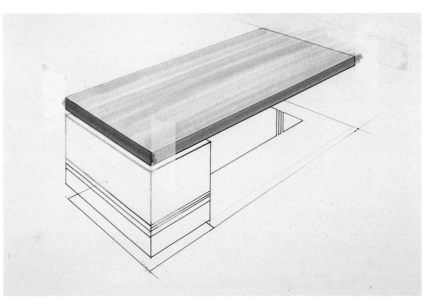

③茶系のマーカー処理が終わった木目部分。

*(3) The wooden area completed with the
brown marker.*

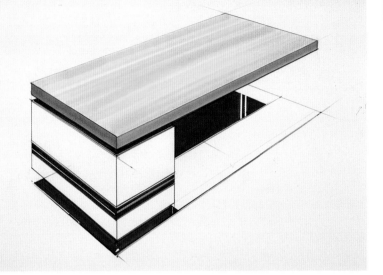

④黒マーカーで簡単にキャストシャドウ等を描いてマーカー処理終了。

(4) Draw in the shadows roughly in black marker to end the marker work.

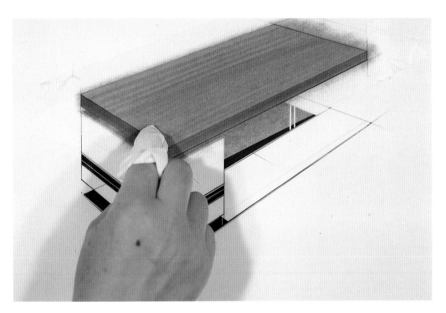

⑤必要部分をマスキングし，粉状にした茶系のパステルをティッシュペーパーにつけて横方向のストロークで塗っていく。

(5) Apply masking where necessary and the apply brown powder pastel using horizontal strokes with a tissue paper.

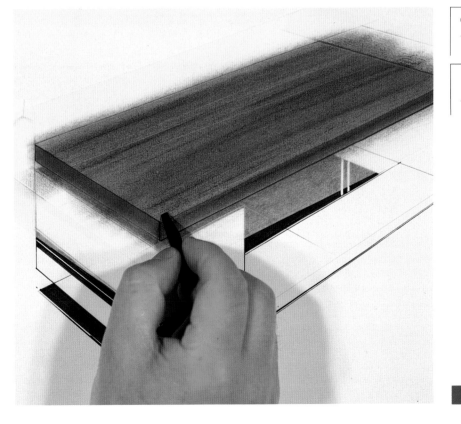

⑥黒のパステルの角で軽く横線をひき，これを指で横方向にぼかすと，簡単に木目が表現できる。

(6) Draw horizontal lines gently using one corner of the black pastel and smear it horizontally with a finger to effectively express the wooden grain.

⑦木目部分にリフレクションをいれる。
必要部分をトレーシングペーパーで縦方向にあ
てがい，ティッシュペーパー又は練りゴムでパ
ステルを軽く拭き取ってリフレクションを表現
する。

*(7) Add some reflection to the wooden grain.
Place a piece of tracing paper vertically on
top of the necessary area and wipe out the
pastel with a tissue paper or soft rubber to
express the reflection.*

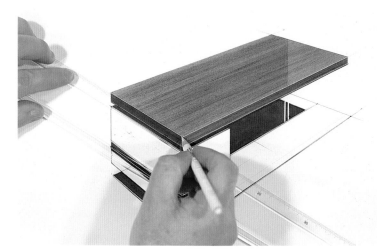

⑧パステル処理が終わった木目パネル。

*(8) The wooden grained panel completed with
pastel work.*

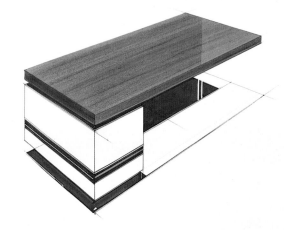

⑨直定規を使い，白のカラーペンシルでハイラ
イトラインを描く。

*(9) Use a ruler to draw in the highlight lines in
white pencil.*

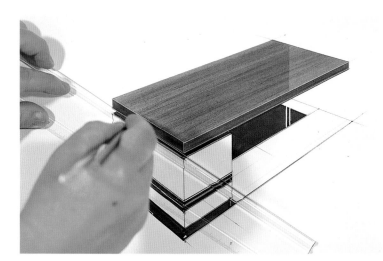

⑩白のポスターカラーでハイライトライン，デ
ザインラインをいれる。
注）直線は溝引きを使ってシャープにいれる。

*(10) Add the highlight lines and design lines
in white poster color.*

茶系のマーカー処理が終わったあと，茶系の粉状のパステルをティッシュペーパーにつけて横方向のストロークで塗る
さらに，黒のパステルの角で軽く横線をひき，これを指で横方向にぼかすと，木目が表現できる
Having been processed by the brown marker, apply some brown powdered pastel to a tissue paper and paint in some horizontal strokes. Use the corner of a black pastel to draw in light horizontal lines, and then shade them off with the use of a finger to express the grain in the wood.

木目部分にリフレクションをいれる
必要部分をトレーシングペーパーで縦方向にあてがい，ティッシュペーパー又は練りゴムでパステルを軽く拭きとってリフレクションを表現する
Add the reflection onto the wood grain. Express the reflection by applying a piece of tracing paper on the part necessary in a vertical position and gently wiping out the pastel with a tissue or a soft rubber.

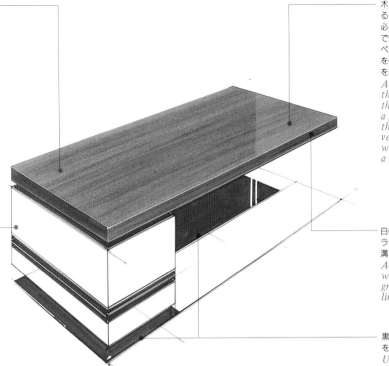

白のポスターカラーでハイライトラインをいれる
溝引きを使ってシャープにいれる
Add the highlight lines in white poster color. Use a grooved ruler to ensure the lines are neat.

ラインドローイングは黒の水性サインペンで
Use a black water-color felt-tip pen for the line drawing.

黒のマーカーでキャストシャドウをいれ画面全体を引きしめる
Use black markers for the shadow to brace up the entire picture.

⑪完成したウッドデスクのスケッチ。
備考）木目パネル以外は省略して描いてある。

(11) The completed sketch of the wooden desk.
NB. Only the process of the wood graining has been explained here.

D-CARを描く *Drawing a D-CAR*

A 2 サイズヴェラム紙 *A2-size vellum paper*

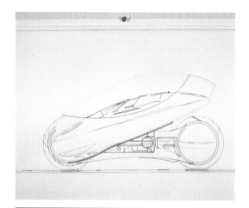

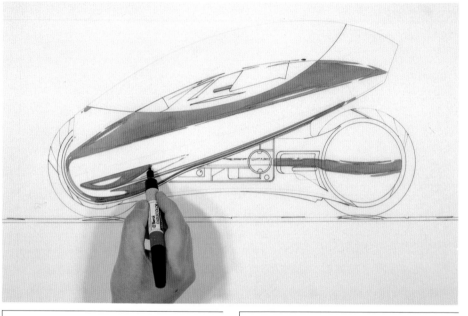

①下描きの上にヴェラム紙を重ね，赤ボールペン，黒ボールペンでラインドローイングする。
注）ボディの曲線部分のデザインライン（外形線）を太くすると立体感に欠けるので，薄く，細く描く。

(1) Place the velum on top of the sketch and draw in the lines in red or black ball-point pen.
NB: Draw the design lines on the curved areas of the body thinly and lightly as a cubic impression will be produced by thick lines.

②赤系の細描きマーカーでリフレクションを描いていく。

(2) Work on the reflections with a red-shade thin marker.

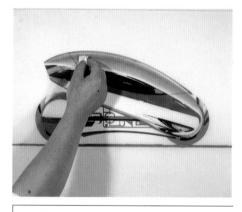

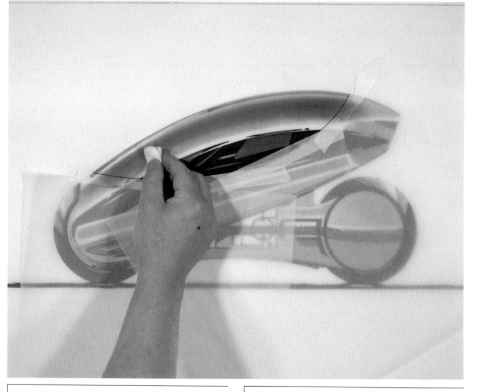

⑤裏面よりパステルワークにはいる。
重ね折りしたネルに粉状の青紫系パステルをつけ，ウィンドウ上部を塗っていく。
明るいリフレクション部分は塗り残しておく。

(5) Go into the pastel work applied from the back of the paper. Paint in the upper section of the window with a double-folded flannel applied with a blue-shade powder pastel. The sections with lighter reflections should be left unpainted.

⑥紙の表面必要部分をマスキングし，パステルで描き進める。
明るいリフレクション部分は塗り残しておく。
備考）粉状のパステルに若干のベビーパウダーを混入すると，滑らかな曲面のグランデーション表現がし易くなる。

(6) Masking should be applied where necessary and the pastel work can begin. The sections with lighter reflections should be left unpainted.
NB: An addition of a small amount of baby powder to the powder pastel will help smooth out the gradation on the curves.

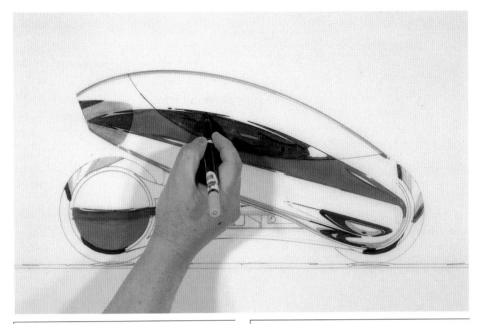

③紙の裏面からも，グレイ，黒のマーカーでリフレクションをいれ，微妙なハーフトーンを表現する。

(3) Also draw in the reflections from the back of the paper using grey and black markers in order to express the fineness of the work in half-tones.

④黒の細描きマーカーでタイヤ，地面の線，ディテールを描いてマーカー処理終了。
備考）ヴェラム紙は不浸透性なので，塗りむらがでて汚くなる。
マーカーで描いたあと，BLAIR MARKER フィキサチーフ（米国製）を軽くかけると綺麗になる。

(4) Draw in the tires, the ground level and the details in a thin black marker to complete the marker work.
NB: Markers don't work well on impermeable velum as they shine too much or lay unevenly. A gentle spray of Blair Marker fixative (US made) will solve this problem.

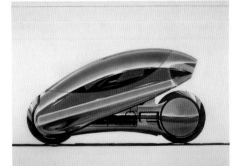

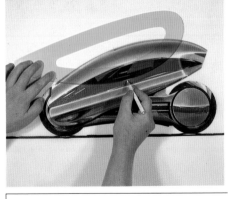

⑦ボディ，ウィンドウ等の明るいリフレクション部分，ハイライトライン，パステルのはみだし部分は練りゴム，鉛筆型消しゴムで拭きとる。スプレーフィキサチーフでパステルを定着してパステル処理終了。

(7) Wipe out the lighter reflections on the body and window, the highlight lines and the excess pastel with a soft rubber or a pencil eraser. Apply the fixative spray to the picture to set the pastel and complete the pastel work.

⑧白のカラーペンシルでハイライトライン，デザインライン，ディテールを描く。
カーブの部分はデザインスイープを使って描く。

(8) Draw in the highlight lines, the design lines and the details in white pencil. Use a design sweep to draw the curves.

⑨白のポスターカラーでハイライトライン，デザインライン等をいれる。

(9) Add the highlight lines and design lines in white poster color.

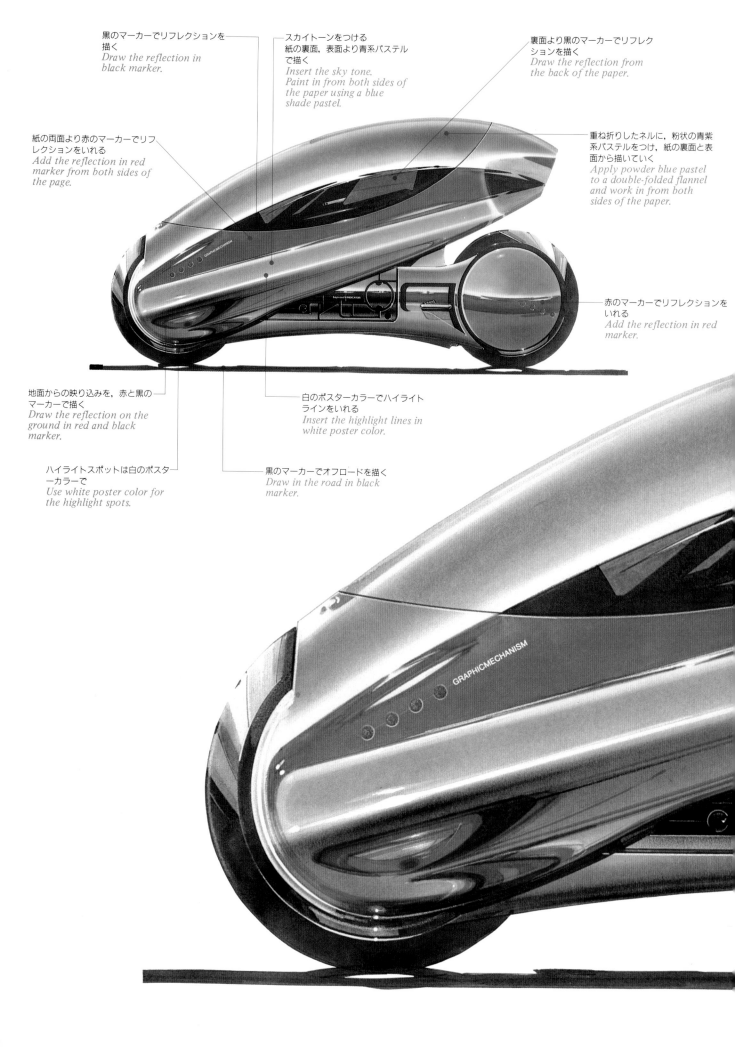

黒のマーカーでリフレクションを
描く
*Draw the reflection in
black marker.*

スカイトーンをつける
紙の裏面，表面より青系パステル
で描く
*Insert the sky tone.
Paint in from both sides of
the paper using a blue
shade pastel.*

裏面より黒のマーカーでリフレク
ションを描く
*Draw the reflection from
the back of the paper.*

紙の両面より赤のマーカーでリフ
レクションをいれる
*Add the reflection in red
marker from both sides of
the page.*

重ね折りしたネルに，粉状の青紫
系パステルをつけ，紙の裏面と表
面から描いていく
*Apply powder blue pastel
to a double-folded flannel
and work in from both
sides of the paper.*

赤のマーカーでリフレクションを
いれる
*Add the reflection in red
marker.*

地面からの映り込みを，赤と黒の
マーカーで描く
*Draw the reflection on the
ground in red and black
marker.*

白のポスターカラーでハイライト
ラインをいれる
*Insert the highlight lines in
white poster color.*

ハイライトスポットは白のポスタ
ーカラーで
*Use white poster color for
the highlight spots.*

黒のマーカーでオフロードを描く
*Draw in the road in black
marker.*

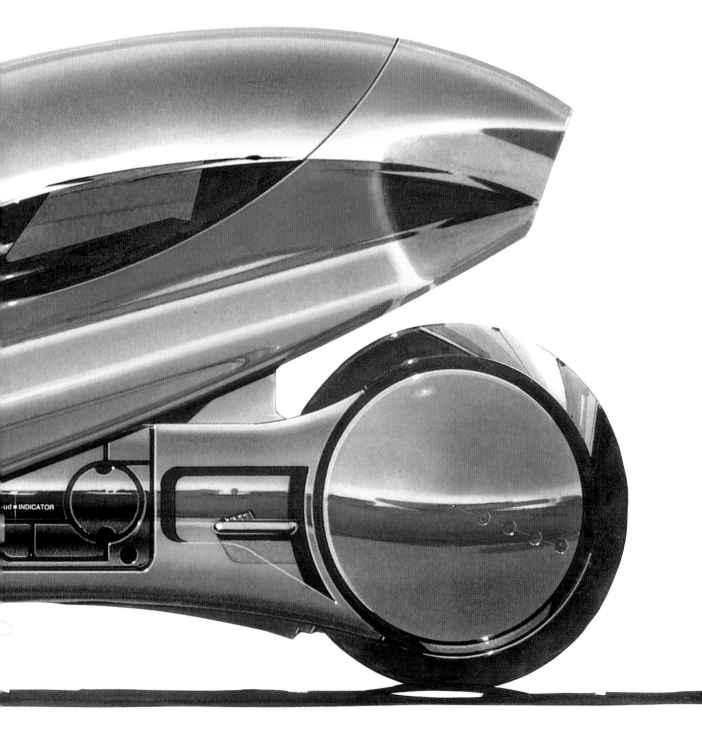

ADコンピュータを描く

Ａ２サイズレイアウトペーパー（ＰＭパッド白） *A2-size layout paper (white PM pad)*

①下描きの上にレイアウトペーパーを重ね，黒水性サインペン，黒ボールペンでラインドローイングする。
コンピュータディスプレイ部分のリフレクション等も軽く線描きしておく。

(1) Place the layout paper onto the sketch and draw the lines in black water-color felt-tip pen and black ball-point pen. The lines of the display reflections should also be drawn in at this point.

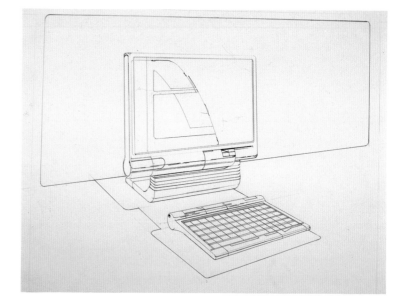

②必要部分をマスキングする。バックの任意の部分にインスタントレタリング（タイトルのＡＤ　ＣＯＭＰＵＴＥＲ）を貼る。

(2) Place the masking onto the necessary sections. Apply the instant lettering (the name of the advanced computer) on the area where the background should be.

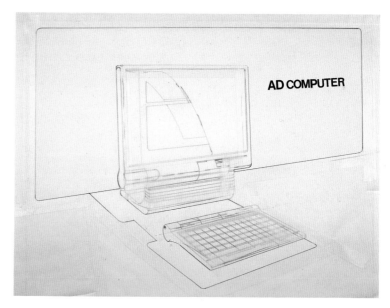

③重ね折りしたティッシュペーパーを金属クリップで挟み，これに赤紫系の液体マーカーをふくませて任意のストロークでバックグラウンドとキャストシャドウを描く。

(3) Draw in the background and shadows with any style of stroke using a double-folded tissue paper held firmly in a metal clip and moistened with a purplish-red liquid marker.

Drawing an Advanced Computer

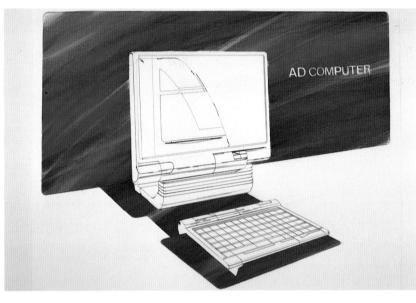

④マスキングをはずす。
タイトルのAD　COMPUTERはセロテープを使ってはがす。

(4) Remove the masking.
Remove the tile "AD COMPUTER" using cellophane tape.

⑤赤，青，黄色，クールグレイ，黒マーカーでディスプレイ部分，キーボード部分，キャストシャドウの部分等を描いていく。

(5) Work on the display and keyboard sections and the shadowing in red, blue, yellow, cool-grey and black markers.

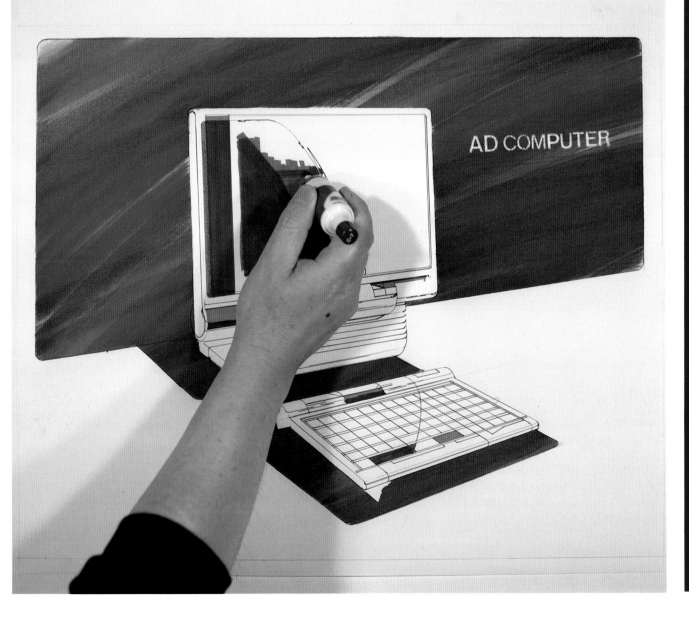

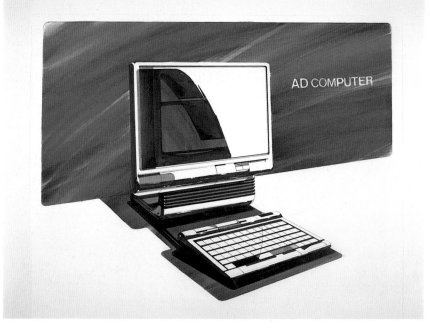

⑥マーカー処理が終わったスケッチ。

(6) The completed sketch with the marker work.

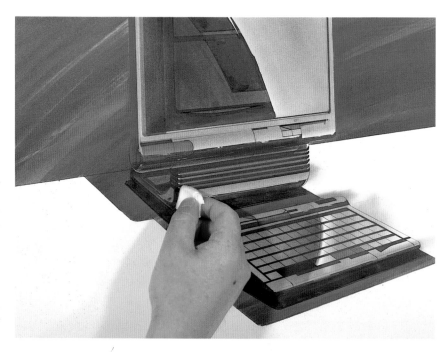

⑦パステルワークにはいる。
重ね折りしたネルに，粉状の紫系パステルをつけ，ディスプレイ，キーボード部分を描く。キーボードの暗いリフレクション部分は黒のパステルを塗る。

(7) The pastel work begins.
Draw in the display and keyboard areas with a double-folded tissue paper applied with a purple-shade powder pastel. Black pastel should be used in the dark reflection area of the keyboard.

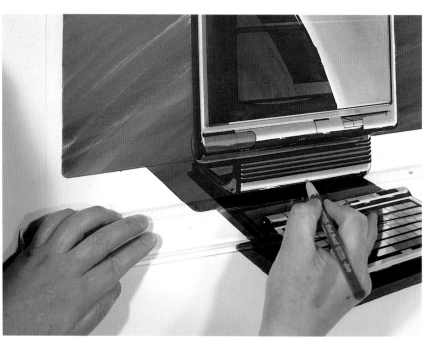

⑧パステルのはみだし，ハイライトライン，デザインライン，リフレクションの明るい部分は定規などを使い，練りゴム，鉛筆型消しゴムで拭き取っていく。

(8) The excess pastel, the highlight lines, the design lines and the light reflection areas should be carefully wiped out with the use of a soft rubber or a pencil eraser with the aid of a ruler.

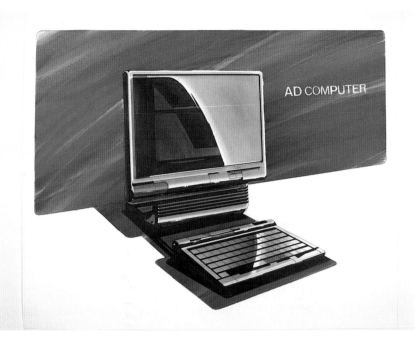

⑨パステル処理終了。

(9) The completed pastel work.

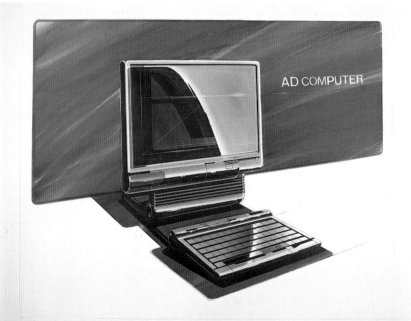

⑩白のカラーペンシルでハイライトライン，デ
ザインライン，ディテールを描く。
白のカラーペンシルによるタッチアップ終了。

*(10) Draw in the highlight lines, the design
lines and the details in white pencil.　The
touch-up with white pencil has been complet-
ed.*

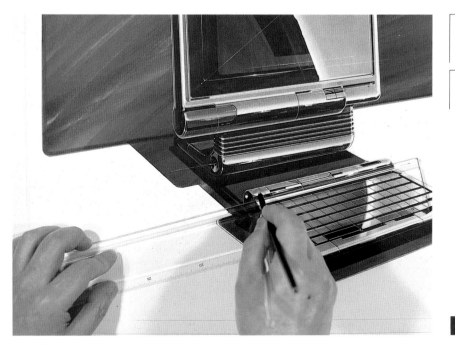

⑪白のポスターカラーでハイライトライン，デ
ザインライン，文字を含むディテールを描く。
直線部分は溝引きを使っていれる。

*(11) Draw in the highlight lines, the design
lines and the details including the letters in
white poster color.*

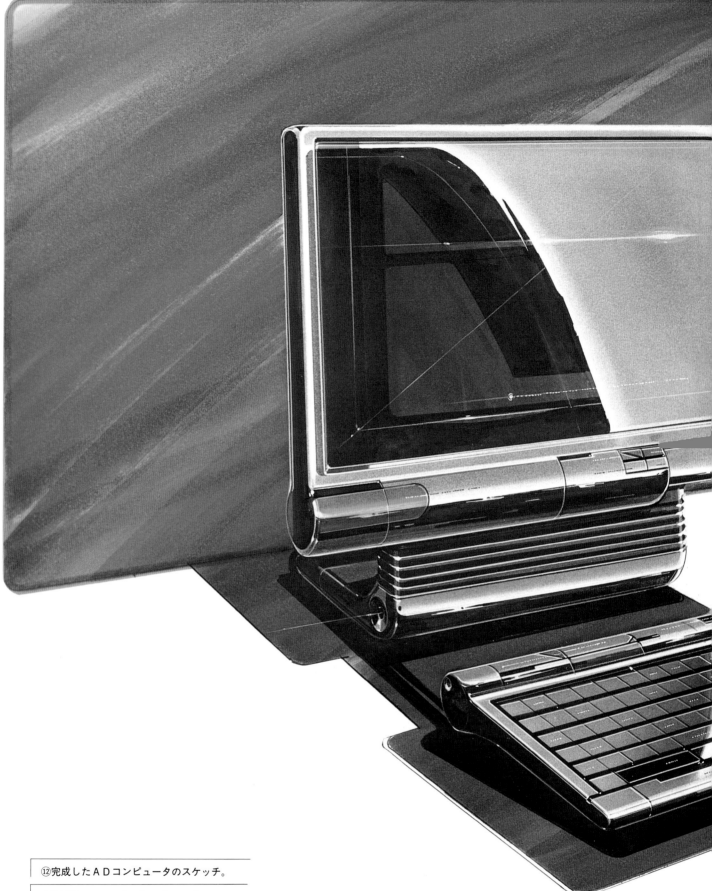

⑫完成したＡＤコンピュータのスケッチ。

(12) The completed advanced computer sketch.

AD COMPUTER

必要部分をマスキングし，重ね折
りしたティッシュペーパーを金属
クリップで挟み，これに赤紫の液
体マーカーをふくませてラフなス
トロークで，バックグラウンドと
キャストシャドウを描く
*Apply masking to the areas
required and dip a double-
folded tissue firmly clasped
in a clip into redish-purple
liquid marker to draw in
the background and shad-
ow in strokes.*

重ね折りしたネルに，粉状の紫系
パステルをつけ，ディスプレイ，
キーボード部分を描く
*Apply purple powder
pastel to a double-folded
flannel and draw in the
display and part of the
keyboard.*

白のポスターカラーでハイライト
ライン，ハイライトスポットをい
れる
*Draw in the highlight lines
and spots in white poster
color.*

黒のマーカーでリフレクションを
描く
*Draw the reflection in
black marker.*

AD COMPUTER

インスタントレタリングによるマ
スキング
*Masking with instant letter-
ing.*

白のカラーペンシルによるデザイ
ンライン
*The white pencil design
lines.*

文字のインディケーションは簡潔
にいれる
*Briefly indicate the letter-
ing.*

明るいリフレクション部分は，練
りゴム，鉛筆型消しゴムでパステ
ルを拭きとる
*Wipe out the pastel for the
lighter reflection areas with
a soft rubber or pencil
eraser.*

The Point of Technique

●ジアゾコピー紙にマーカースケッチを描く。トレーシングペーパーに基本的なパースライン等を描き，これを複写機にかけ，コピーしたジアゾ紙にマーカー等でスケッチする。

同一形体のビルディングや物体のデザインバリエーションスケッチを多く描く場合とか，決められたパースアングルで多くのデザインスケッチを描く場合，その基本的なパースライン等が既にコピーされているのでラインドローイングは著しく早くなる。

又，ジアゾ紙は浸透性紙のため，マーカーが滲みこんで水墨画の"ボカシ"のような効果がでるため，表面が梨地などマットフィニッシュの物体の表現に適しているといえる。

Draw the basic perspective lines onto tracing paper and put this through a mimeograph machine to copy it onto the diazotized paper. Use a marker to draw the sketch onto it.

When it is necessary to draw many pictures of the same shape drawing or design variation sketches of substances or several sketches from certain perspective angles, the line drawing work becomes extremely easy if the basic perspective lines have already been copied onto the paper.

Additionally, this paper is ideal for expressing substances with cracked surfaces or matt finished surfaces as the marker will permeate the paper to produce a natural shading effect.

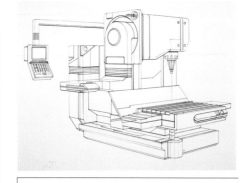

①トレーシングペーパーに黒の鉛筆又はサインペン等で基本的な線描きをし，複写機にかけコピーする。

注）マシニングセンターは大きいので，パースにおける視線（目の位置）は低めに設定し，マシニングセンター"らしい大きさ"に表現する。ここではコントロール部（ＣＲＴ）より少し高いところを視線にした。

(1) Draw the basic lines on a piece of tracing paper in black pencil or felt-tip pen and then run it through the mimeograph to copy it.
NB: The size of the machining center should be expressed by setting the perspective position of the eyes rather low. It should be the size of a machining center. Here the eye was set to the position a little higher than the control section (CRT).

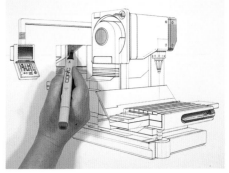

②機械の色部分，明るい部分を任意の色マーカー，クールグレイNo.１〜No.６で描いていく。

注）ジアゾ紙は浸透性紙なので，マーカーの塗りムラができやすい。

マーカーを紙に軽く押しつけながら，左から右，右から左に，あるいは上から下に，下から上に往復するように塗っていくとムラができにくい。

(2) Draw the colored and lighter section of the machine in any color marker and cool-grey No. 1 ~ No. 6.
NB: Being permeable, diazotized paper tends to make the markers paint unevenly. This can be prevented by working the markers from left to right, right to left or top to bottom whilst pressing lightly on the paper.

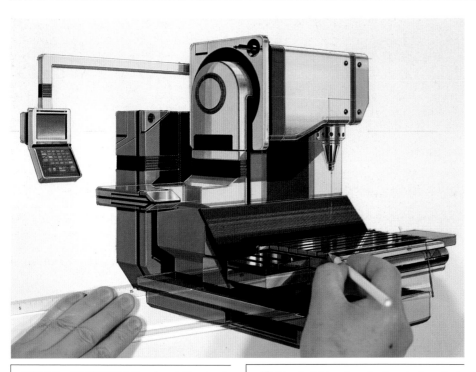

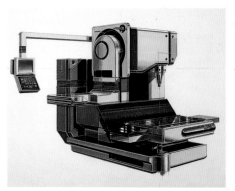

⑧白のカラーペンシルによってハイライトライン，デザインラインがはいったスケッチ。

(8) The sketch with the highlight lines and design lines in white pencil.

⑦直定規，楕円定規等を使い白のカラーペンシルでハイライトライン，デザインラインを入れていく。

(7) Use straight and oval rulers to draw in the highlight lines and design lines in white pencil.

Drawing a Machining Center

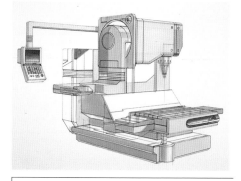

③機械の色部分，明るい部分のマーカー処理完了。

(3) The completed marker work for the colored and light parts of the machine.

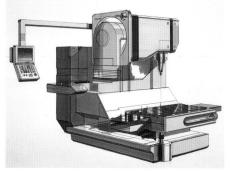

④機械の陰影部分や，暗い部分はクールグレイのNo. 7 〜No.10を使って描き進めていく。

(4) Work on the shadow and dark parts of the machine using cool-grey No. 7 ~ No. 10.

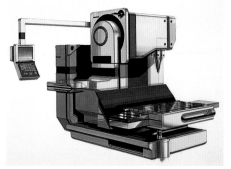

⑥陰影部分やリフレクションにポスターカラーの黒を使ってスケッチ全体を引きしめる。

備考）黒のポスターカラーを陰影部分等に使うことで，めりはりのある，いわゆるコントラストのきいたスケッチとなる。
工作機械のダイナミックさを表現するには，このような手法が効果的であろう。

(6) Use black poster color for the shadow areas and reflection in order to brace up the entire sketch.
NB: A picture with a strong contrast can be produced by using black poster color in the shadow areas. This method is seemingly effective to express a dynamic appeerence of the machine tools.

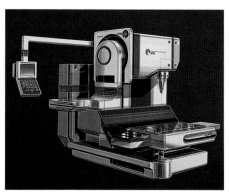

⑤マーカー処理が終わったスケッチ。

(5) The sketch with the marker work complete.

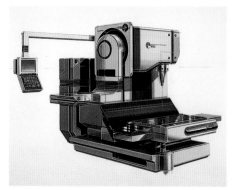

⑨白のポスターカラーで，ハイライト部分，デザインライン等を入れてスケッチは完成。
注）白のポスターカラーを使い，溝引きの手法でハイライトライン，デザインラインを入れていく。
操作パネル等の文字のインディケーションは特別の理由がないかぎり簡潔で抽象的とする。

(9) Complete the sketch by adding highlight lines and design lines in white poster color.
NB: Use white poster color to add the highlight lines and design lines utilizing the grooved ruler technique. Letter indication in such areas as the operation panel should be done concisely and abstractly unless there are reasons to do otherwise.

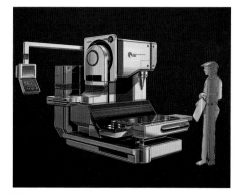

⑩より強いコントラスト効果をだすために，完成したスケッチ⑨をカットアウトし黒のバックボード（ここではイラストレーションボード）に張る。
備考）スケッチをボードに張るには，スプレーボンド，幅広のダブルテープ等を使用する。ここでは，３Ｍのデザインボンドを使った。

(10) Stick the cut out completed sketch (9) onto a black backboard (an illustration board has been used here) in order to produce a stronger contrast.
NB: Use spray bond and wide double tape for sticking the sketch onto the board. 3M design bond has been used here.

⑪人物を描き入れることにより，マシニングセンターの大きさが充分に理解できる。

(11) The size of the machining center can be indicated by inserting a person.

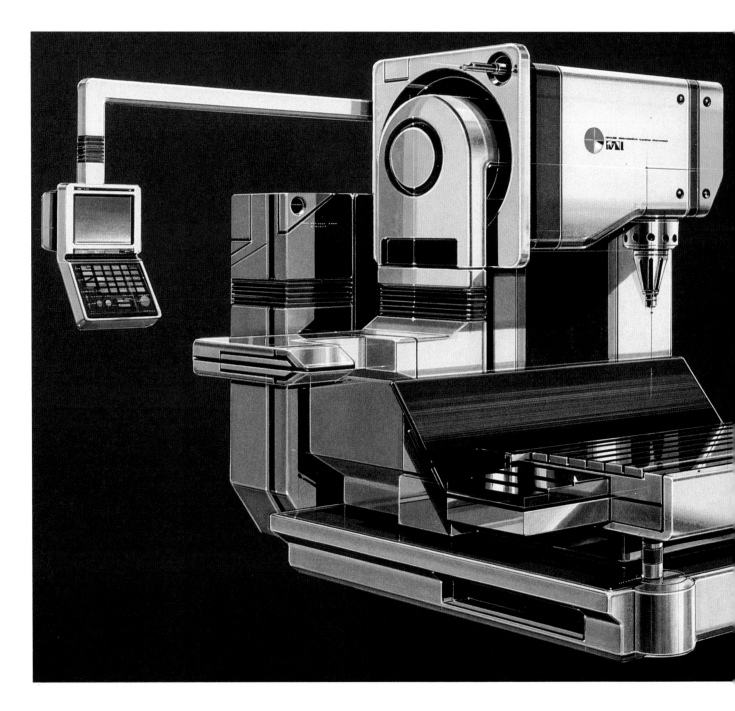

⑫完成したマシニングセンターのスケッチ。

(12) The completee sketch of the machining center.

文字のインディケーションは白の
ポスターカラー等で簡潔にいれる
*The lettering indications
should be drawn in simply
with white poster color.*

黒イラストレーションボード
*The black illustration
board.*

基本的なパースラインがコピーさ
れたジアゾ紙に黒の水性サインペ
ン（太さ0.2㎜位）でラインドロー
イングする
*Draw lines on the diazo-
tized paper on which the
basic perspective lines have
been copied using a black
water-color flet-tip pen
(about 0.2mm in thick-
ness).*

シルバーのカラーペンシルによる
線描き
*The line drawing in silver
colored pencil.*

クールグレイマーカーNo. 7～No.10
の重ねぬりでスチールの光沢感を
表現する
*The shiny texture of the
steel is expressed by using
cool-grey markers number-
ed between No. 7 and No.
10 and painted over and
over.*

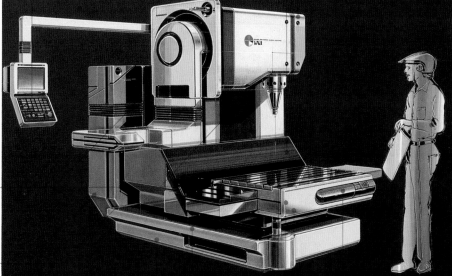

ポスターカラーの黒で陰影をいれ
強いコントラストをつける
*Mark in the strong contrast
by adding shadow with
black poster color.*

白のカラーペンシルでデザインラ
イン，ハイライトラインを描く
*Draw in the design and
highlight lines with a white
color pencil.*

コントラスト（めりはり）のきい
たスケッチにするために，完成し
たスケッチをカットアウトし黒の
イラストレーションボードにはる
*Cut out the complete
sketch and attach it to a
black illustration board to
improve the contrast.*

白のポスターカラーでハイライト
ラインを描く（溝引きによる）
*Draw in the highlight lines
with white poster color
(using a grooved ruler).*

クールグレイマーカーのボカシぬ
り
*Painted by graduation of
the cool grey markers.*

人物を配し，マシニングセンター
の大きさがわかるようにする。
注）人物はあまり写実的に描き込
まないほうがよい
*Give a hint to the size of
the machinery by inserting
a person.
(NB) It is better not to
draw the person too
graphically.*

AVルームを描く *Drawing an AV Room*

B3サイズレイアウトペーパー（PMパッド白）*B3-size layout paper (white PM pad)*

①下描きの上にレイアウトペーパーを重ね，黒
水性サインペン（0.2～0.3㎜程度）でラインド
ローイングする。
画面の周囲をマスキングする。
備考）ここでは一消点パースで線描きした。

(1) Place the layout paper on top of the sketch and draw in the lines with black water-color felt-tip pen (0.2 ~ 0.3mm). Apply the masking to the area around the picture.
NB: Perspective has been used to draw in the lines.

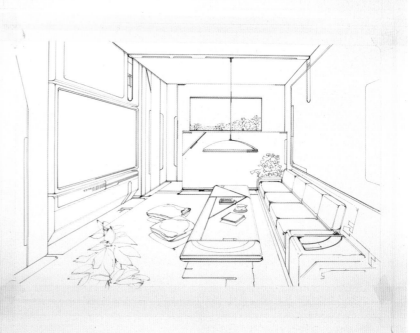

②壁面と映像画面をマスキングして，重ね折り
したティッシュペーパーを金属クリップで挟み，
これに任意の色の液体マーカーをふくませ，ラ
フなタッチで描く。

(2) Apply the masking to the wall and the reflected picture and draw in a rough touch manner using a double-folded tissue paper held firmly in a metal clip and moistened with any optional liquid marker.

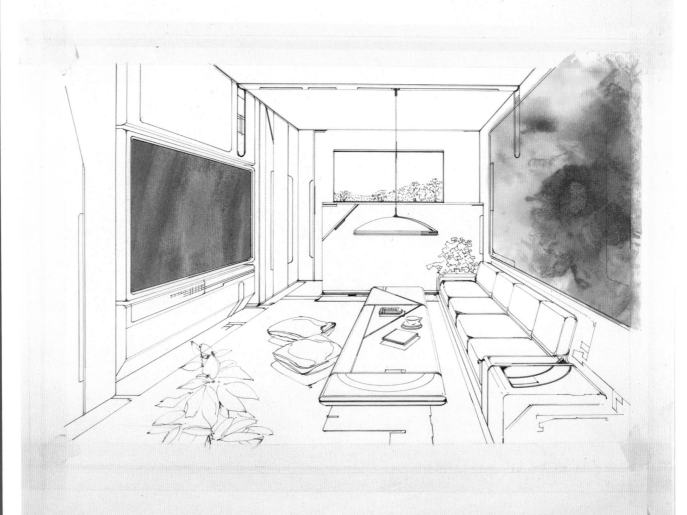

③グリーン系マーカーで植物，窓の外の樹木等
を描いていく。

(3) Work on the pot-plants and the outside trees with green-shade markers.

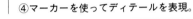

④マーカーを使ってディテールを表現。

(4) Use markers to express the details.

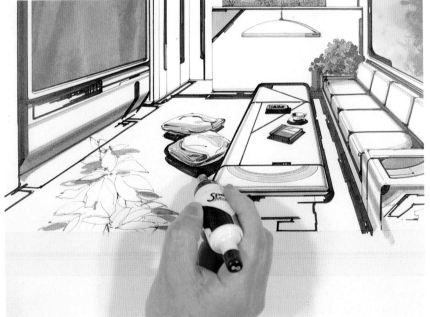

⑤黒のマーカーでクッション，テーブル等のキ
ャストシャドウ，ディテールを描き，画面を引
きしめる。（めりはりをつける）

(5) Brace up the picture by adding shadow and details to the cushions and table in black marker (to add distinction to the picture).

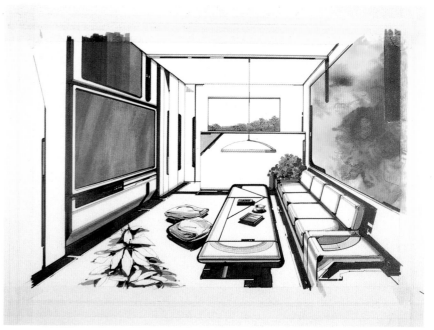

⑥マーカー処理が終わったスケッチ。

(6) The sketch with the marker work completed.

⑦パステルワークにはいる。
重ね折りにしたネルに，粉状の薄いブルーグレイ系パステルをつけ，壁面，テーブル，ソファー等をソフトタッチで描いていく。

(7) The pastel work begins.
Add a gentle touch and work it into the wall, table and sofa, etc., using a double-folded flannel applied with a lightblue/grey shade of powder pastel.

⑧ハイライト部分，パステルのはみだし等は消しゴム，練りゴムで拭きとり，スプレーフィサチーフでパステルを定着してパステルワーク終了。
画面の周囲のマスキングをはずす。

(8) Wipe out the highlight lines and the excess areas of pastel with an eraser or soft rubber and apply the fixative spray to set the pastel and complete the pastel work.

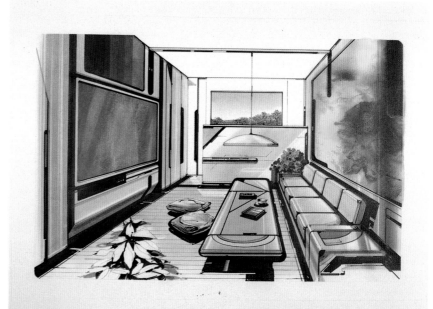

⑨直定規を使い，白のカラーペンシルでハイライトライン，デザインライン，ディテールを描く。

(9) With the aid of a straight ruler, draw in the highlight lines, design lines and details in white pencil.

⑩白のカラーペンシルによってデザインライン，ハイライトライン等がはいったスケッチ。
白のカラーペンシルによるタッチアップ終了。

(10) The sketch with the design lines and highlight lines drawn in white pencil. The white-line touch-up is complete.

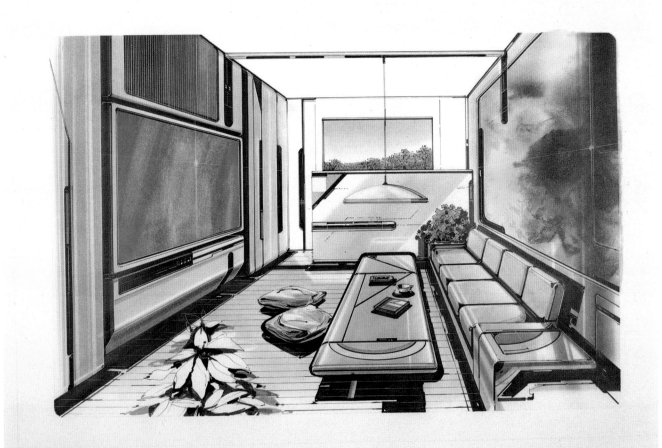

⑪白のポスターカラーで，ハイライトライン，デザインライン，ディテールを描く。
直線部分は溝引きを使ってシャープにいれる。

(11) Draw in the highlight lines, the design lines and the details in white poster color. Use a grooved ruler to draw straight and clear lines.

白のカラーペンシルでディテール,
デザインラインを描く
*Draw in the details and
design lines in white
pencil.*

ピンクのマーカーでアクセントを
つける
*Add the accent with a pink
marker.*

重ね折りしたネルに，粉状にした
うすいブルーグレイ系パステルを
つけ，壁面，テーブル，ソファー
等を塗っていく
*Apply a light blue/grey
pastel to the double-folded
flannel to paint in the wall.*

ラインドローイングは黒の水性サ
インペンで
*Use a black water-color
felt-tip pen for the line
drawing.*

映像画面と同様，液体マーカーで
描く
*Use the same liquid marker
as the picture screen to
draw this.*

植物は簡潔に表現する
*Simplify the expressing the
plants.*

黒のマーカーでクッション，テー
ブル，ソファー等のキャストシャ
ドウ，ディテールを描き，画面を
引きしめる（めりはりをつける）
*Use a black marker to draw
in the shadow of the cu-
shions, table and sofa in
order to brace up the
picture (add contrast).*

映像画面をマスキングして，重ね
折りしたティッシュペーパーを金
属クリップで挟み，これに黄，青
の液体マーカーをふくませ，ラフ
なタッチで描く
*Apply masking to the pic-
ture screen, and using a
double-folded tissue in a
metal clip dipped in yellow
and blue marker solution,
paint it in with a rough
touch.*

白のポスターカラーで，ハイライ
トライン，ハイライトスポットを
いれる
直線部分は溝引きを使ってシャー
プにいれる
*Add the highlight lines and
spots in white poster color.
Use a grooved ruler to
draw the lines neatly.*

⑫完成したＡＶルームのスケッチ。
備考）あらためて画面全体をながめ，必要があ
れば手を加える。

(12) The completed sketch of the AV room. NB: Alternations should be added to the areas necessary having looked at the finished picture as a whole.

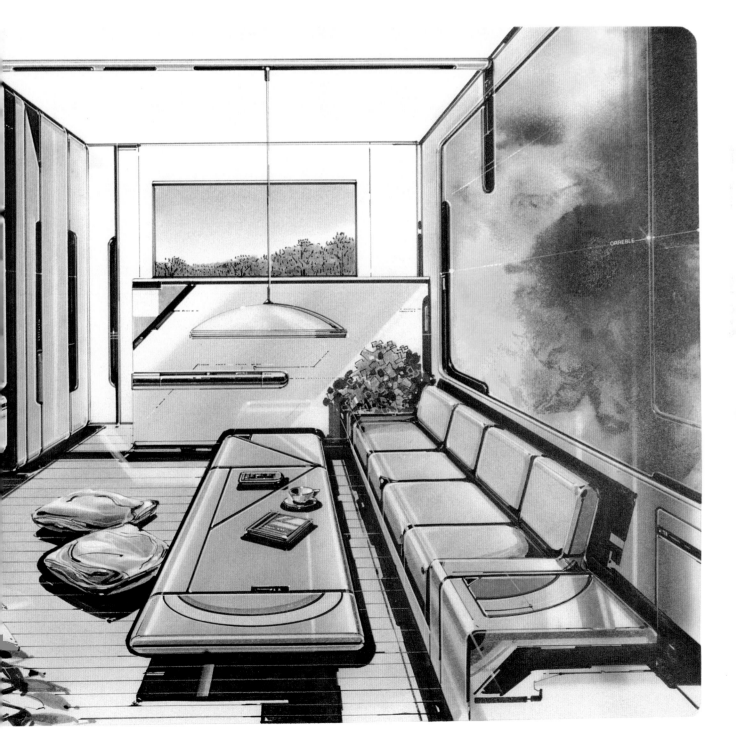

⑫完成したＡＶルームのスケッチ。

マーカー＋コンピュータによる スケッチ2作例

2 SKETCHES BY MARKER AND COMPUTER

作画　杉山久志＋清水吉治
ILLUSTRATIONS BY: HISASHI SUGIYAMA/YOSHIHARU SHIMIZU

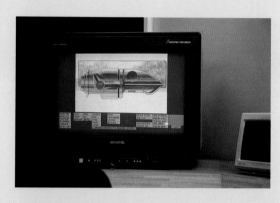

東洋美術学校第一デザイン研究室，
英国クォンテル(QUANTEL)社の
システムを使用

TOYO ART AND DESIGN SCHOOL
UTILIZING THE BRITISH QUANTEL CO. SYSTEM

　マーカーでラインドローイングとバックを描いたデータを，スキャナー入力し，スタイラスペンによりエアブラシ，パステルのタッチで描いていく。

　軽く描くと薄く，強く描くと濃く，ペンの筆圧で描く。描く人のタッチが，ハイビジョンモニター（2000本以上の高解像度によって実現した精密な画像）上にリアルタイムに表現される。

　描き終わったあと，カラーの変換，合成をイメージに合わせおこなう。

　基本的に手で描く作業と同じで，コンピュータを使っている感覚はまったくない。

　データ処理はデジタルだが，作業はアナログである。これは，普段，手で描いているデザイナーにとって大変ありがたいことである。

Input the marker-line data and background with a scanner and then begin to draw in the same style as airbrushing and pasteling with the use of the stylus pen.
Work in the same way as if one is using a pen; press gently for a light touch and harder for a thick touch. The touch of the pen will be displayed on the high-vision monitor (a precision picture consisting of over 2000 high resolution dots) real time.
Once the picture has been completed, alterations and color composition may be added to adjust the image.
Basically the drawing is carried out in the same way as all hand drawings and will not feel as if one is using a computer.
The data processing is digital, but the operation is analog. This is appreciated by those designers who usually draw by hand.

スピニングリールを描く

Drawing a Spinning Reel

① 黒の細描きマーカーでラインドローイングし，スキャナー入力する。

(1) Draw the lines in thin black marker and input it with the scanner.

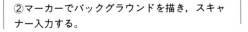

② マーカーでバックグラウンドを描き，スキャナー入力する。

(2) Draw the background in marker and input it with the scanner.

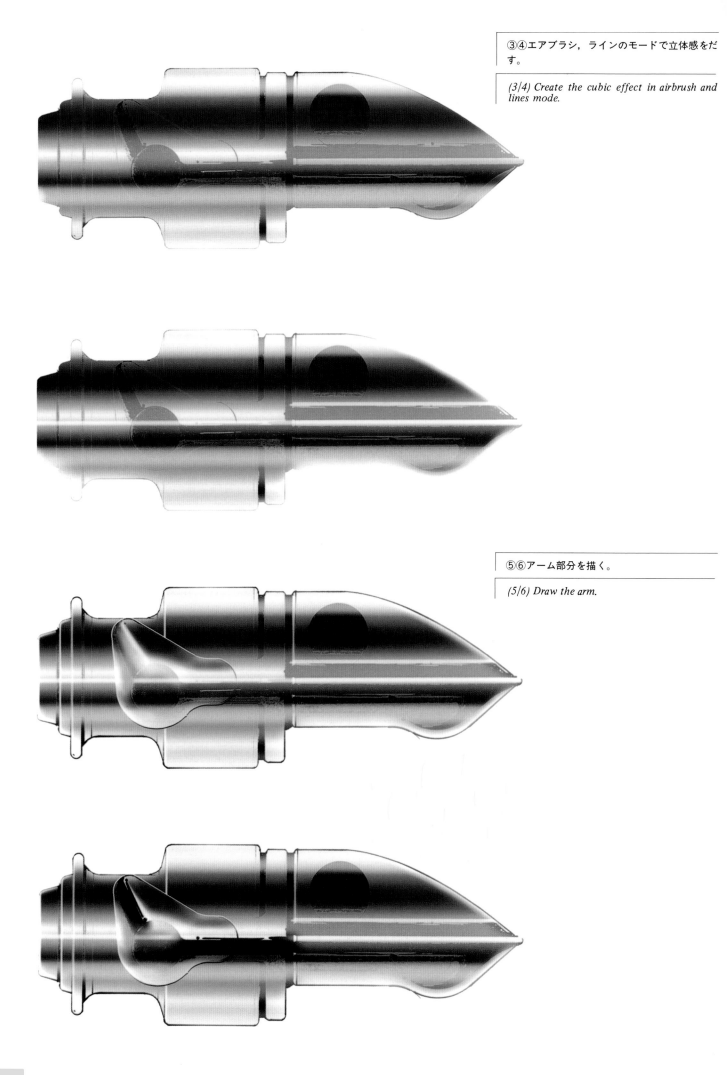

③④エアブラシ，ラインのモードで立体感をだ
す。

(3/4) Create the cubic effect in airbrush and lines mode.

⑤⑥アーム部分を描く。

(5/6) Draw the arm.

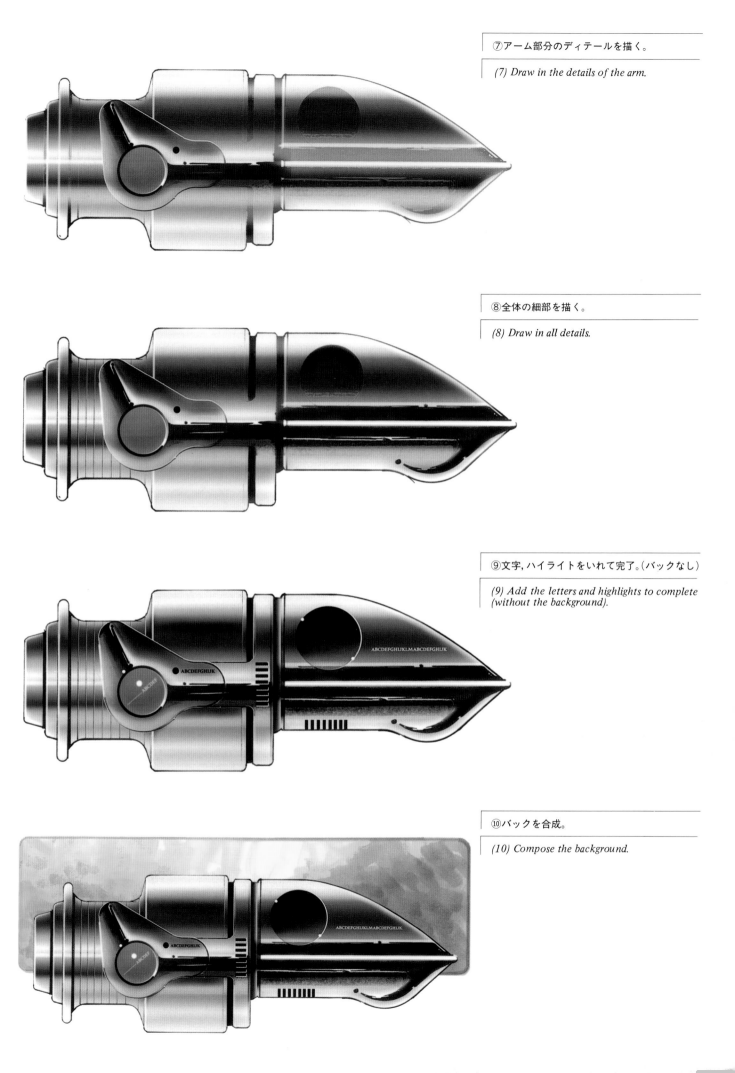

⑦アーム部分のディテールを描く。

(7) Draw in the details of the arm.

⑧全体の細部を描く。

(8) Draw in all details.

⑨文字，ハイライトをいれて完了。（バックなし）

(9) Add the letters and highlights to complete (without the background).

⑩バックを合成。

(10) Compose the background.

⑪カラーカーブを利用し映り込みをいれる。
完成。

(11) Add the shadow by using color curves. Completion.

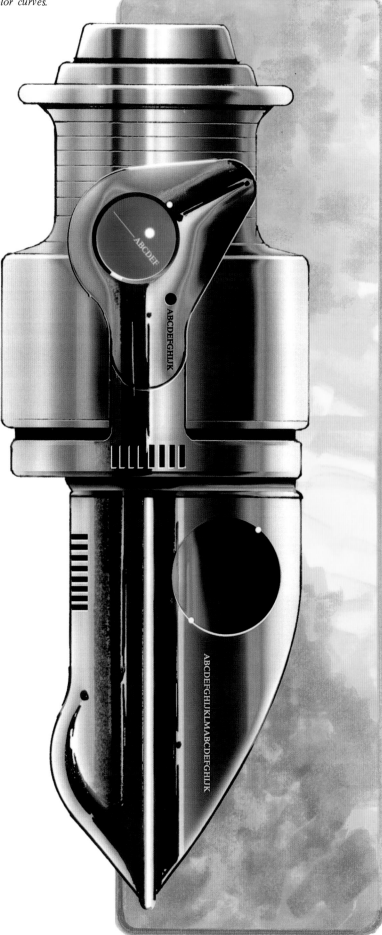

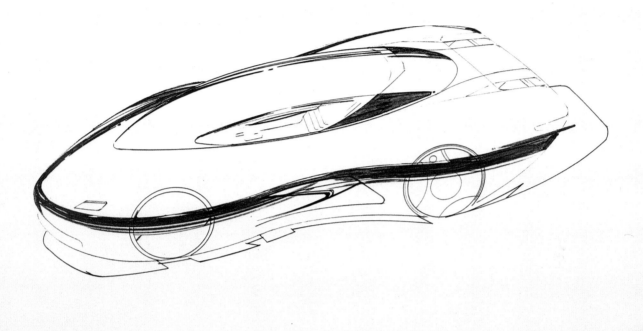

①黒の細描きマーカーでラインドローイングし，スキャナー入力する。

(1) Draw the lines in a thin black marker and input it with the scanner.

②マーカーと液体マーカーでバックグラウンドを描き，スキャナー入力する。

(2) Draw in the background in ordinary marker and liquid marker and then input it with the scanner.

③車全体に地の色をペイント。

(3) Paint the entire car in ground colors.

④マスクを利用し濃い部分に色をいれる。

(4) Use masking to color the darker section.

⑤エアブラシ機能を使いハイライトをいれる。

(5) Work on the highlights using the airbrush technique.

⑥⑦ボディにエアブラシで濃淡をつける。

(6/7) Add the shading to the body using the airbrush.

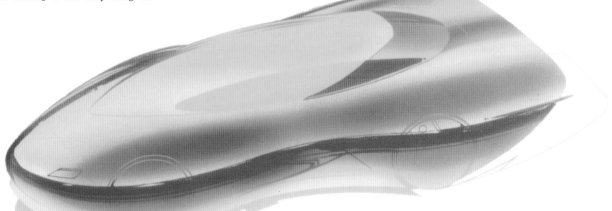

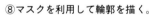
⑧マスクを利用して輪郭を描く。

(8) Use masking to draw the outlines.

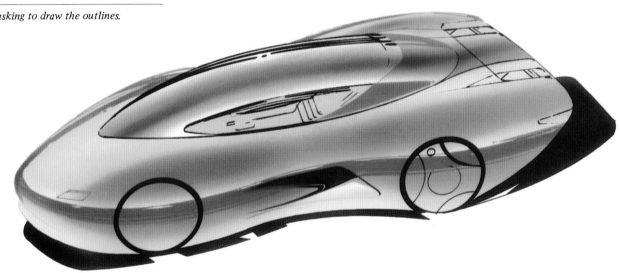

⑨映り込みを描く。

(9) Add the body reflections.

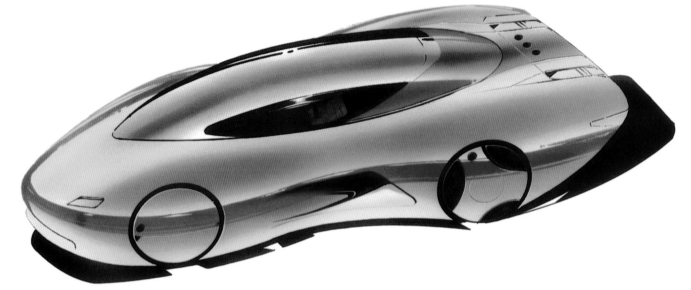

⑩ハイライトをエアブラシで描き完了。（バックなし）

(10) Draw in the highlights with an airbrush to complete. (Without the background).

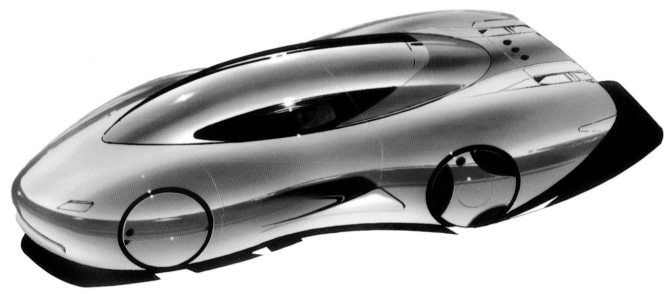

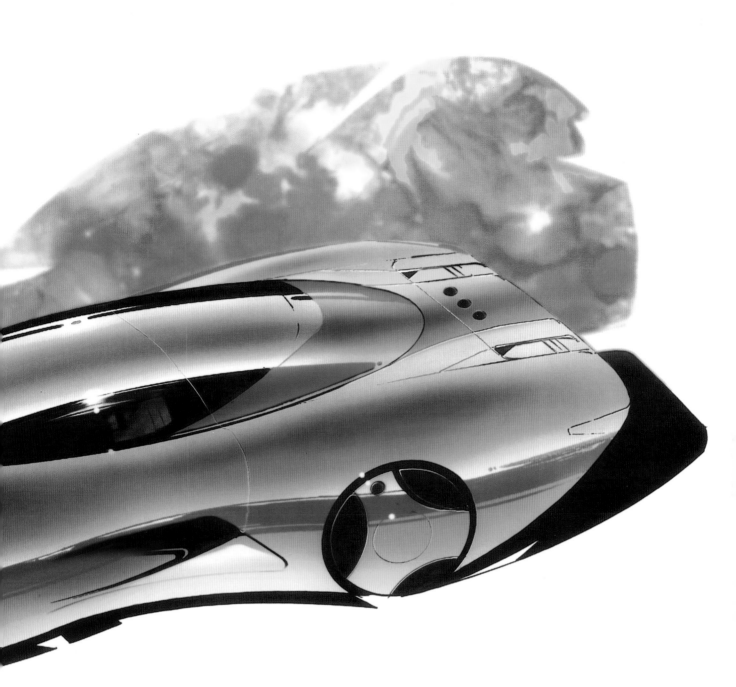

⑪車とバックを合成して完成。

(11) Compose the car and background to finish.

⑫車を色変換し合成。（同じ車を 2 台に増やす）

(12) Compose the cars by adding alternations in colors. (Draw one more of the same car).

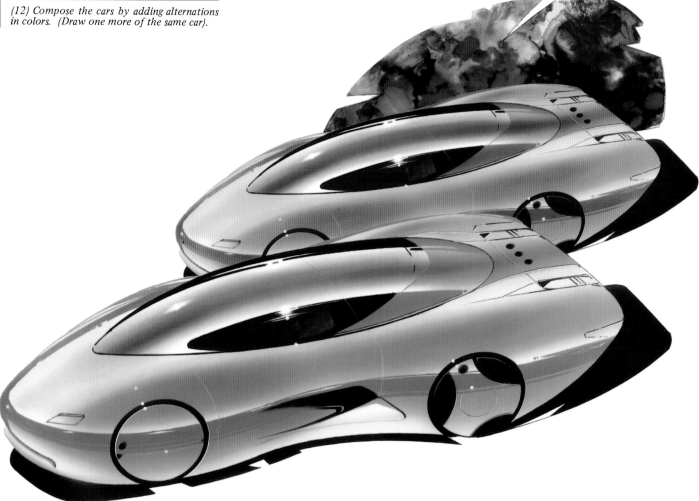

ギャラリー

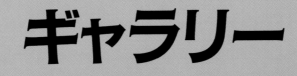

WORKS

作品名————————CDプレーヤー
使用目的————————デザイン・プレゼンテーション
使用画材————————マーカー，ポスターカラー
用紙————————青写真用感光紙
原画サイズ————————350㎜×530㎜
制作年————————1987年

Title of Work————CD PLAYER
Employed Form————DESIGN PRESENTATION
Employed Art Materials————MARKER AND POSTER COLOR
Employed Board————BLUEPRINT PAPER
Original Size————350㎜×530㎜
The Year Produced————1987

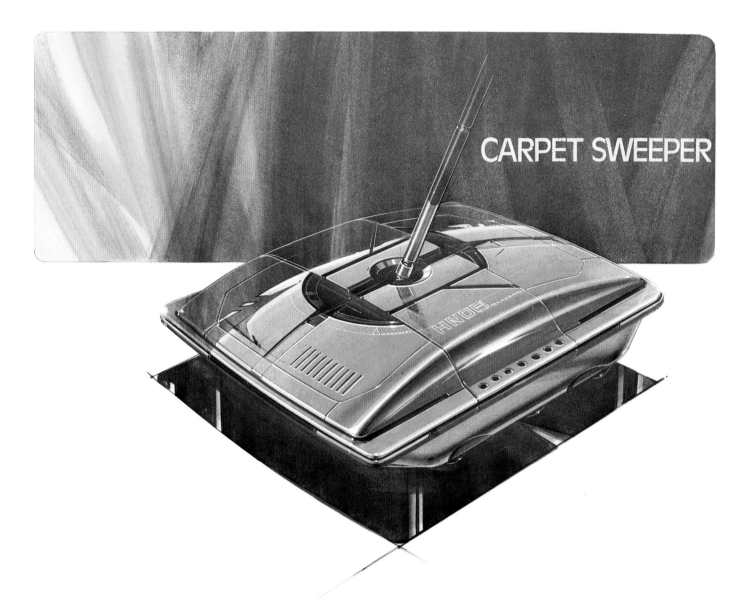

CARPET SWEEPER

作品名————カーペット・スイーパー
使用目的————デザイン・プレゼンテーション
使用画材————マーカー，パステル，他
用紙————ヴェラム紙
原画サイズ————350㎜×490㎜
制作年————1988年

Title of Work————CARPET SWEEPER
Employed Form————DESIGN PRESENTATION
Employed Art Materials————MARKER AND PASTEL
Employed Board————VELLUM PAPER
Original Size————350㎜×490㎜
The Year Produced————1988

carpet sweeper

作品名————カーペット・スイーパー	Title of Work————CARPET SWEEPER
使用目的————デザイン・プレゼンテーション	Employed Form————DESIGN PRESENTATION
使用画材————マーカー，パステル，他	Employed Art Materials————MARKER AND PASTEL
用紙————ヴェラム紙	Employed Board————VELLUM PAPER
原画サイズ————350㎜×490㎜	Original Size————350㎜×490㎜
制作年————1988年	The Year Produced————1988

COMPACT & UNIVERSAL TYPE CLEANER

作品名————コンパクト・クリーナー
使用目的————デザイン・プレゼンテーショ
使用画材————マーカー，パステル，他
用紙————PMパッド白
原画サイズ————210㎜×300㎜
制作年————1987年

Title of Work————COMPACT CLEANER
Employed Form————DESIGN PRESENTATION
Employed Art Materials————MARKER AND PASTE
Employed Board————WHITE PM PAD
Original Size————210㎜×300㎜
The Year Produced————1987

ELECTRO
MAG. WALL
RADIO TV
RYER

ELECTROMAGNETIC
ENJOY BATHROOM

COOLER
HEATER
JET BATH

作品名————ボトル
使用目的————デザイン・プレゼンテーション
使用画材————マーカー，パステル，他
用紙————ヴェラム紙
原画サイズ————400㎜×560㎜
制作年————1987年

Title of Work————BOTTLE
Employed Form————DESIGN PRESENTATION
Employed Art Materials————MARKER AND PASTEL
Employed Board————VELLUM PAPER
Original Size————400㎜×560㎜
The Year Produced————1987

作品名————バスルーム
使用目的————デザイン・プレゼンテーション
使用画材————マーカー，パステル，他
用紙————PMパッド白
原画サイズ————300㎜×420㎜
制作年————1987年

Title of Work————BATHROOM
Employed Form————DESIGN PRESENTATION
Employed Art Materials————MARKER AND PASTEL
Employed Board————WHITE PM PAD
Original Size————300㎜×420㎜
The Year Produced————1987

作品名―――スタジオ・モニター
使用目的―――デザイン・プレゼンテーション
使用画材―――マーカー，パステル，他
用紙―――PMパッド白
原画サイズ―――310㍉×490㍉
制作年―――1990年

Title of Work―――STUDIO MONITOR
Employed Form―――DESIGN PRESENTATION
Employed Art Materials―――MARKER AND PASTEL
Employed Board―――WHITE PM PAD
Original Size―――310㍉×490㍉
The Year Produced―――1990

作品名————スタジオ・モニター・テレビ
使用目的————デザイン・プレゼンテーション
使用画材————マーカー，パステル，他
用紙————ヴェラム紙
原画サイズ————340㎜×480㎜
制作年————1990年

Title of Work————STUDIO MONITOR T.V.
Employed Form————DESIGN PRESENTATION
Employed Art Materials————MARKER AND PASTEL
Employed Board————VELLUM PAPER
Original Size————340㎜×480㎜
The Year Produced————1990

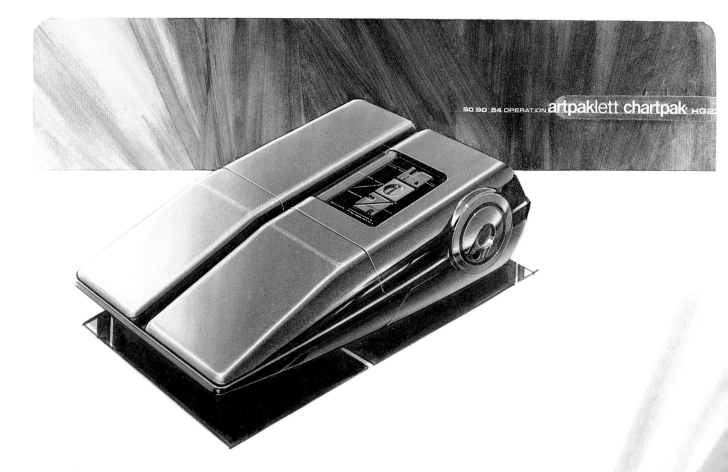

作品名————テレフォン
使用目的————デザイン・プレゼンテーション
使用画材————マーカー，パステル，他
用紙————ヴェラム紙
原画サイズ————350㎜×460㎜
制作年————1987年

Title of Work————TELEPHONE
Employed Form————DESIGN PRESENTATION
Employed Art Materials————MARKER AND PASTEL
Employed Board————VELLUM PAPER
Original Size————350㎜×460㎜
The Year Produced————1987

作品名————ADクリーナー
使用目的————デザイン・プレゼンテーション
使用画材————マーカー，パステル，他
用紙————ヴェラム紙
原画サイズ————360㍉×520㍉
制作年————1987年

Title of Work————ADVANCED CLEANER
Employed Form————DESIGN PRESENTATION
Employed Art Materials————MARKER AND PASTEL
Employed Board————VELLUM PAPER
Original Size————360㍉×520㍉
The Year Produced————1987

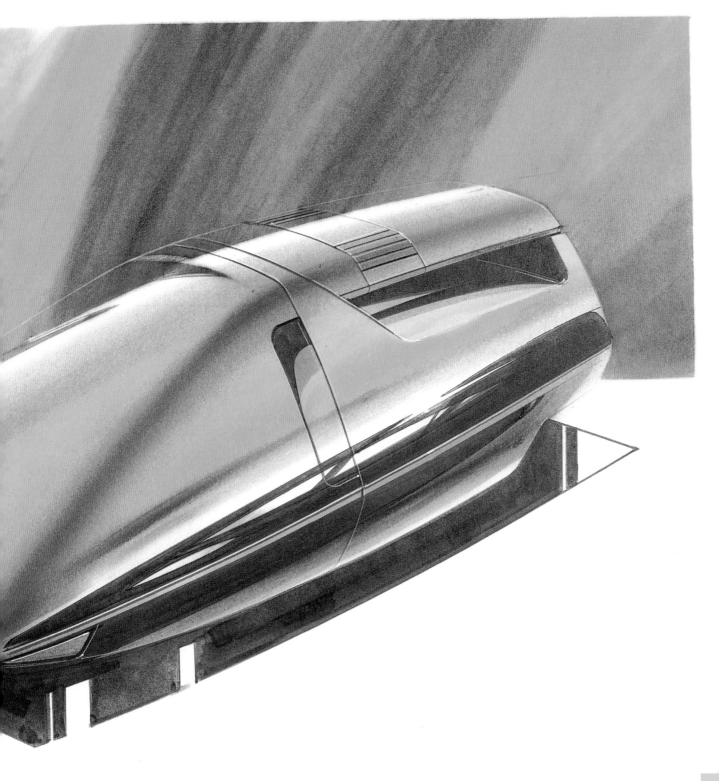

あとがき

　この本を書くには，結構苦労した。

　すでに製品になっているありふれた物を描くのでは，クリエーティブスケッチにならないし，本がでる頃には，もう古くなっていることだろうし。

　日常のデザイン業務では，ある程度気軽に？スイスイとスケッチが描けるのだが，本になり，多くの人達の目にふれると思うと，頭の回転が悪くなり，新しい造形がうかんでこない，当然のことながら手が動かない。

　最初の頃は，今日がだめなら明日やればよいといった調子でいたが，時間がどんどん経過し，脱稿の日が近づくにつれ焦ってきた。

　なんとかアイデアが浮かび，線描きした時点でスケッチプロセスを撮影のため一時中断，また描きだして中断，撮影のくりかえしで，完成したスケッチはどうも流れに乗っていないような感じがし，気に入らないので描き直し，また線描きからスタートし，中断，撮影と着色をくりかえし完成，また気に入らないので描き直し，一体いつになったら一つの作例が完成するのかわからない。

　やっとこのような変則スケッチワークのペースをつかんだ頃には，殆どが終わりに近い状態だった。

　不満足ながら18以上のスケッチデモンストレーションを載せることが出来た。

　終わりに，推薦文をいただいた平野拓夫，豊口協の両先生，本書の出版の機会を与えてくださったグラフィック社と最後まで面倒をおかけした編集部の山田信彦氏，ブック・デザインを担当していただいた大貫伸樹氏，それからコンピュータによるスケッチ表現に協力いただいた東洋美校の杉山久志先生には，深く感謝いたします。

<div align="right">清水吉治</div>

Much elaborate work has gone into the completion of this book. Common products were not suitable objects for the sketches as they do not offer the necessary creativity, and they might even go out of fashion before the book went to press.

To some extent I can sketch much quicker and in a much more relaxed manner when I am working in my office. However, the thought that the work I was doing would end up in a book and be open to view for many people dried up my idea reservoir. My head refused to cooperate, and naturally this stopped the movement of my hands.

At first the thought of what I was doing did not bother me in the least. I worked out a schedule of what would be done on which day, but as time passed I began to panic as the deadline for submitting the work grew nearer. Somehow I managed to come up with some ideas, but I had to keep stopping to photograph the sketch process at regular intervals. These interruptions caused a lack of rhythm in my work, so I started the process all over again. I would draw a little and then stop to take some photographs, insert the color and take some more photographs. This was repeated until the sketch was complete, but once again the finished product would not appeal to me and I would start all over again. At times I dispaired at ever finishing.

At last I managed to accustome myself to the necessary pace, but by then I had nearly come to the end of the project. In spite of all these struggles, I finally managed to draw more than 18 demonstration sketches for the book.

To end, I would like to extend my deepest gratitude to Mr. Takuo Hirano and Mr. Kyo Toyoguchi — both of whom are my teachers and provided me with recommendation letters — to the Graphic-sha Publishing Co. Ltd. who gave me the opportunity to publish this book, to Mr. Nobuhiko Yamada of the editorial department who was kind enough to put up with all the troubles until the end, to Mr. Shinju Onuki who was in charge of the book design, and to Mr. Hisashi Sugiyama of the Toyo Art and Design School who was kind enough to offer his help for the computer sketches.

Yoshiharu Shimizu

筆者紹介

清水吉治 (しみず よしはる) 工業デザイナー

1934年長野県生まれ。1959年金沢美術工芸大学美術工芸学部産業美術学科工業意匠卒業後，（株）富士通ゼネラルDセンター等を経て，
Studio Nurmesniemi，フィンランド国立美術工芸大学留学。現在，（財）日本機械デザインセンター，（財）生活用品振興センター，
（財）日本産業デザイン振興会，各企業内デザイン研修講師。埼玉県，石川県デザインアドバイザー。多摩美術大学，東京工芸大学，
東洋美校講師。多摩美術大学二部，神戸芸術工科大学，武蔵野美術大学，新座総合高専攻科，OCAなど特別講師。
著書に「VTR教材・マーカースケッチ」（財）日本機械デザインセンター，「マーカーワークスinジャパン」（編），
「モデリングテクニック」（共著）グラフィック社など。1959年毎日IDコンペスポンサー賞（グループ），1987年特許庁（財）発明協会意匠賞，
1988年中華民国対外貿易発展協会意匠貢献状，1989年繊維機械で金沢市長賞など。（社）JIDA会員。

住所　〒350-12　埼玉県日高市武蔵台5-29-12
　　　Tel. 0429-82-1914

参考文献

●清水吉治　工業デザイン全集第4巻・デザイン技法・スケッチ　　日本出版サービス1982
●糖沢・J. ジョセフ　　アイデア・プレゼンテーション用ラフスケッチの要点　カースタイリング'8 1974
●RENDERING IN MIXED MEDIA BY JOSEPH UNGAR　　WATSON-GUPTILL PUBLICATIONS 1985
●VITA CRAFTリーフレット　　サントリーショッピングクラブ 1986
●ダブリンのデザイン透視図法　J. ダブリン　鳳山社　1980

マーカー・テクニック

1990年 9 月25日　初版第 1 刷発行
1990年11月25日　初版第 2 刷発行
1991年 2 月25日　初版第 3 刷発行
1991年 5 月25日　初版第 4 刷発行
1992年 4 月15日　初版第 5 刷発行
1992年 8 月25日　初版第 6 刷発行

著　者―――――清水吉治ⓒ
発行者―――――久世利郎
印　刷―――――錦明印刷株式会社
製　本―――――錦明印刷株式会社
写　植―――――三和写真工芸株式会社
発行所―――――株式会社グラフィック社
　　　　　　　　〒102　東京都千代田区九段北1-9-12
　　　　　　　　☎03(3263)4318　Fax.03(3263)5297
　　　　　　　　振替・東京3-114345
　　　　　　ISBN4-7661-0580-X C3052